# A–Z

OF

# ELY

PLACES - PEOPLE - HISTORY

Michael Rouse

AMBERLEY

*For all those who love our city and serve to make it even better*

First published 2018

Amberley Publishing
The Hill, Stroud, Gloucestershire, GL5 4EP
www.amberley-books.com

Copyright © Michael Rouse, 2018

The right of Michael Rouse to be identified as
the Author of this work has been asserted in
accordance with the Copyrights, Designs and
Patents Act 1988.

ISBN  978 1 4456 8344 7 (print)
ISBN  978 1 4456 8345 4 (ebook)

British Library Cataloguing in Publication Data.
A catalogue record for this book is available
from the British Library.

Origination by Amberley Publishing.
Printed in Great Britain.

# Contents

# Introduction

There were earlier settlements on the small fenland island of Ely, but it is accepted that the story of Ely goes back over 1,300 years to when St Etheldreda established her religious house in 673. Today Ely and its parish, which includes the small hamlets and villages of Chettisham, Prickwillow, Queen Adelaide and Stuntney, is a city of some 19,000 and growing.

To select the entries for an A–Z is bound to be rather quirky and personal, but through this selection of well-known buildings and features, some sadly lost, and people who lived in the city, I hope the history of Ely emerges.

My thanks to all those who over the years have helped me learn so much about Ely, including the late Reg Holmes, Pamela Blakeman MBE, Mike Petty MBE, Cecil Dye – for this book particularly, for notes on the Archer family – and Andy Bone and Owen Blake for information on Standen Engineering.

Unless otherwise stated in the caption all the photographs were taken by me in 2018.

Michael Rouse

Ely, 2018

# A

## Alan of Walsingham

Alan of Walsingham was a skilled goldsmith who rose from being a monk to sacristan of the cathedral in 1321, and who was responsible for the fabric of the building. In February 1322 he was faced with disaster when the central Norman tower of the cathedral collapsed, possibly affected by work on the Lady Chapel, which had begun the previous year, although there are reasons to believe that it was already unstable. Out of this disaster Alan of Walsingham designed the unique octagonal lantern tower, one of the great glories of medieval architecture and construction. It took twenty year to complete and stands today as a testament to his genius and knowledge of mechanics.

With Prior Crauden, he was also responsible for that little jewel of a chapel, Prior Crauden's Chapel, in The College.

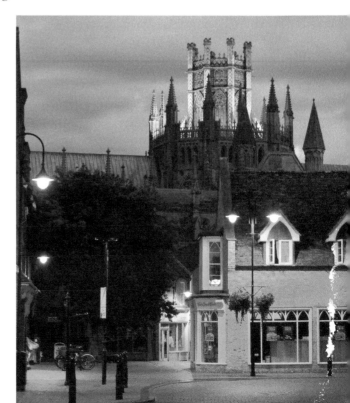

The lantern tower or octagon of Ely Cathedral.

In 1341 Alan of Walsingham became prior and was twice elected as bishop, in 1344 and again in 1361, but the appointment was overruled by the Pope. Alan of Walsingham died in 1364 and is buried in the cathedral, but his great works live on all around him.

# Archer Family, The

The Archer family of solicitors were arguably the most powerful figures in Ely during the nineteenth and the first half of twentieth centuries. Thomas Pennystone Archer, born in 1765, was the first of five generations coming to Ely in around 1800 in partnership with H. R. Evans in High Street Passage. In 1825, he set up his own practice with his son, Thomas, born in 1785. It was this Thomas Archer who rode through the night to Bury St Edmunds in 1816 to summon the dragoons to come to Ely to quell the Ely and Littleport Riots.

Thomas Archer was the foremost authority on drafting local land drainage acts and the family continued to be experts in this field, thus dealing with most of the powerful local landowners and farmers. In 1832 Thomas Archer purchased the mansion house on the Market Place with its extensive land. Named Archer House, it became both his home and office.

Goodwyn Archer, his son, joined the family firm in 1835, and his son, Harold Archer, born at Archer House in 1845, was the next generation, followed by his son Goodwyn Luddington Archer, a distinguished territorial soldier. He had no children, so before his death in 1962 he passed the business on to his nephew John Beckett.

By marriage the Archer family were connected with Evans, the Ely solicitors, and Halls, the brewers, and Harold Archer was married to Sophia Luddington, daughter of Henry Luddington, who lived at Egremont House after James Cropley, to whom his family were also linked by marriage. No family was better connected or more influential through the business or as Ely Urban District councillors.

The firm continues today in Archer House as Ward Gethin Archer.

Archer House, Market Place.

# B

## Babylon

This is the part of Ely cut off from the city when the River Ouse was straightened and diverted closer to the town in around 1100 and further isolated when the railway ran through the land behind in 1845. Referred to in an early thirteenth-century survey as 'Beyond the water', it became known as Babylon – 'across the waters in Babylon' – sometime in the seventeenth century.

Cottages continued to be occupied until the early part of the twentieth century but gradually fell into disrepair, leaving Babylon to boatbuilding, first by the Appleyard family and then by Harry Lincoln, who built the bridge in 1964, making the old chain ferry near the Annesdale Quay redundant.

Today most of Babylon is covered by two large marinas, a workshop and offices, which are owned by Jalsea Marina and the King's Ely boathouses.

Babylon: an entrance to one of the marinas.

# Beet Sugar Factory

There is an area of lagoons next to Queen Adelaide Way that is a legacy of when Ely had a beet sugar factory. One of the consequences of the tragedy of the First World War was the realisation that the country was reliant on imported cane sugar. The answer was to increase home-produced sugar from sugar beet, and the fens were ideal for beet production.

A site was found at Queen Adelaide alongside the River Ouse and next to the railway for the building of the largest factory Ely had ever seen. It was close to where the old Ely port of Turbotsey had once been. Some 1,000 men were employed in the factory's construction on the 66-acre site. For local men in the early 1920s this was welcome work, not only in the construction of the factory but also when it was operational.

In 1925, the factory was ready for its first campaign when some 500 workers were employed. Beet was carted to the factory not only by road, but also by strings of barges. The factory wharf could take thirty barges, and the factory had its own fleet of steel barges and tugs and there were cranes to lift the beet into the factory from the river.

The beet factory became one of the largest local employers and in February 1939 the Ely Beet Sugar Factory Sports Club opened on Lynn Road, with a bowling green and two hard tennis courts.

During the campaign, those winter months when the factory was in full production, everyone was used to the lorries and tractors piled high with beet on the roads and the sweet smell that drifted on the wind. In 1981, however, the factory closed and sugar production was switched to other factories at Bury St Edmunds, Wissington and Peterborough. The Ely site was acquired by the Potter Group and is now a distribution centre, taking advantage of the railway siding that runs into the site. The Beet Club on Lynn Road continues to provide a social and entertainment venue for members.

Potter Logistics at Ely Beet Sugar Factory site.

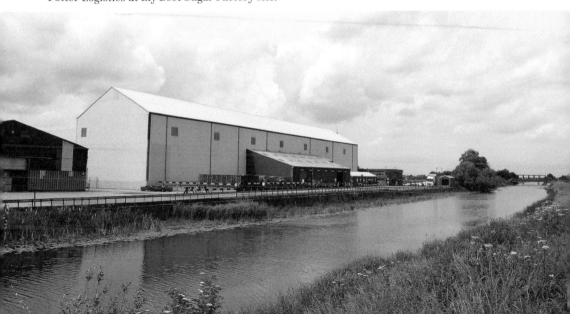

# Bentham, James

James Bentham wrote the magnificent *The History and Antiquities of the Conventual Church of Ely*, published in 1771 after fifteen years of research while he was a canon at the cathedral. That could stand alone as his monument but he also had an eye on the future as well as the past. He proposed a scheme of turnpike roads in 1757 and eventually, with the support of Bishop Mawson, Ely was connected to Cambridge, Littlport, Soham and Sutton by these toll-paying highways.

In 1779, to mark his seventieth birthday he planted an avenue of oak tree on the Lynn Road, which is why that part of the road is known as the Oakery. There is an obelisk in a private garden at the corner of Lynton Close carrying the inscription 'May this benefit the next generation'. He also remodelled the old castle mound in the park and created Cherry Hill.

He was the son of the Revd Samuel Bentham, also a canon and vicar of Witchford. After his education at King's Ely he went to Trinity College Cambridge, being awarded a BA, before holding several livings in Norfolk and becoming a canon at the cathedral in 1737. He died in 1794 at the age of eighty-six, and some of his oak trees still stand as a reminder of a remarkable man.

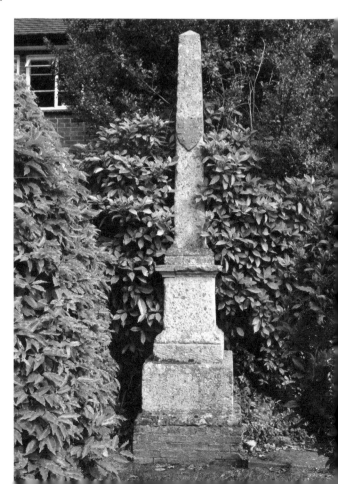

Bentham obelisk at the Oakery, Lynn Road. (By kind permission of Mr David Heaps)

# Bishop's Palace

The Old Palace that runs alongside Palace Green in front of the west end of the cathedral was built by Bishop Alcock, who was bishop from 1486–1500, and it was one of many palaces owned by various bishops over the centuries. Much altered over the years, the long gallery was built by Bishop Goodrich in 1549–50 and the palace remodelled by Bishop Laney during his time at Ely between 1667 and 1675.

In the lovely walled grounds is one of the largest oriental plane trees in England, which is believed to have been planted by Bishop Gunning (1675-1684) and named by the Tree Council as one of the fifty Great British Trees to celebrate Queen Elizabeth's Golden Jubilee in 2002.

Bishop Wynn moved out of the palace in 1941 into what is now the Bishop's House and the Red Cross took over the building as a convalescent home for wounded servicemen. After the war it became a home and secondary school for disabled girls, which went coeducational in 1977. In 1983 it became a Sue Ryder home, but when that closed in 2012, King's Ely carried out an extensive renovation and it is now the Sixth Form Centre, which was opened on 28 September 2012 by HRH Katherine, Duchess of Kent.

Bishop's Palace from the garden.

# Bolton, Tom

Thomas Samuel Bolton (1879–1943) was a superb photographer and chronicler of Ely life and events. His mother, Martha, was a photographer and he continued the family business. He was also an early pioneer of the cinema in Ely and his sister Rose married local tobacconist Henry Churchyard and they built Ely's first cinema in Market Street in 1912.

As well as studio portraits in his shop near the foot of Fore Hill, he took his bulky camera and tripod out to record events and scenes around the town, all shot on glass plates. Published as postcards, those photographs today command premium prices and are an invaluable record of local history and personalities.

During the First World War Tom Bolton was a photographer with the Royal Flying Corps. Sadly his glass plates were destroyed after his death.

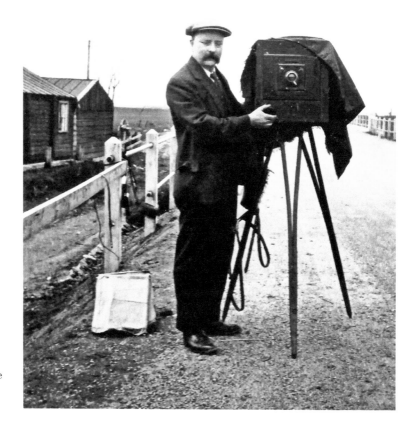

Tom Bolton, the photographer, c. 1920s.

# Breweries

From the days of the monastery Ely was well known for its brewing. The local water was unsafe to drink, but beer was safe and it was made at various strengths using locally grown barley and malt.

Ely was remarkable for its number of public houses and there were several small breweries, but eventually in the nineteenth century there were four principal commercial breweries: the small Eagle brewery in Cambridge Road, Legge's Brewery in Newnham Street, the Waterside brewery and the Quay Brewery.

Two major families began to dominate the market: the Harlocks and the Halls. John Harlock owned the Three Crowns public house in Waterside in 1771 and the Quay Brewery. Ebenezer Harlock built a new Maltings at Quayside in 1868. The Hall family bought Marche's brewery at Waterside in 1700 with its adjoining maltings. Both these breweries had the advantage of being next to the river for transporting goods.

In 1871, Halls built a new brewery at the foot of Fore Hill and transferred there. In 1912, Frank Litchfield Harlock joined forces with William Cutlack of Littleport Brewery and expanded the Quayside brewery.

In 1930 Hall, Cutlack and Harlock was formed and all brewing moved to the Fore Hill Brewery. In 1950 this became East Anglian Breweries, then in 1957 merged with Steward and Patterson of Norwich. In 1963, Watney Mann took over the business and in 1969 closed Ely's last brewery, ending centuries of tradition in the city.

Old Ely Brewery at Fore Hill.

# C

## Cambridge University Boathouse

The River Ouse at Ely has for over a century been used for training by the Cambridge University crews for the annual university boat race against Oxford University, which began in 1829 with a challenge by Charles Merivale, a student at St John's College, Cambridge, and his friend Charles Wadsworth of Christ Church, Oxford. Charles Merivale later became Dean of Ely from 1869–94. The race has been rowed annually since 1839 on the Thames, only interrupted by the two world wars. In 1944, the race was rowed north of Ely on the straight between Littleport and Queen Adelaide, celebrated in Ely as Diamond 44 in 2004, which led to the formation of the Isle of Ely Rowing Club.

Cambridge University Boathouse from the Isle of Ely Rowing Club.

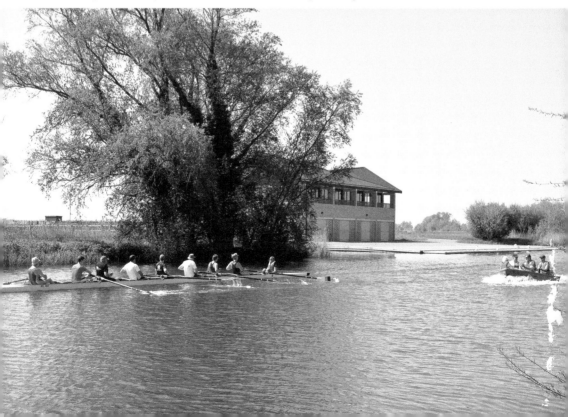

The university originally used the boathouse at Annesdale, now the Grand Central restaurant, before moving to a new boathouse on Babylon next to King's Ely. In December 2016 a new boathouse for all the Cambridge University rowing clubs was opened on Fore Mill Wash just north of the city.

# Cannon on the Green

It may appear incongruous to have a large cannon on Palace Green in front to the west end of the cathedral, but it was a gift to the city in 1860 for raising the Ely Volunteer Rifle Corps. It is a Russian cannon captured from the Battle of Sebastopol in the Crimean War. It was conveyed by train accompanied by the Band of the Grenadier Guards and hauled through the city before being placed with some difficulty on the concrete base for all to admire.

Since then many locals believed it was used by Oliver Cromwell to knock down the missing north-west transept of the cathedral, the city authorities resisted attempts for it to be taken away for scrap during the Second World War and countless children have sat upon it.

Russian cannon on Palace Green.

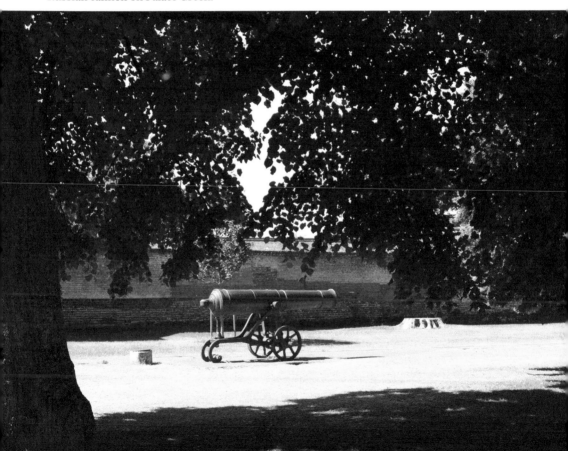

# Castles

Yes, Ely once had two castles. The first was a Norman motte-and-bailey construction, the earthworks of which remain in the park, with the motte or mound remodelled by James Bentham into Cherry Hill. This was built to ensure Norman domination over the rebel island of Ely after Hereward and his followers were finally defeated in 1071.

As Ely stood on an island surrounded by water, marsh and swamp it was a natural stronghold and the scene of much conflict.

Bishop Nigel, appointed to Ely in 1133, was treasurer to Henry I and an important figure at the court, but after the king's death on 1 December 1135 and the outbreak of the civil war between Stephen and Matilda, Bishop Nigel built a stone castle at Ely somewhere at Annesdale, close to the river and the Cawdle Fen stream that entered the river there. The name Castlehythe or Castelhythe, as it is spelt differently at either end of the row, was restored to the area after the Second World War and is the only sign that there was once a castle there.

It seems that the old Norman castle was destroyed around 1216 and Bishop Nigel's castle was similarly dismantled around 1267 after some rebel barons, known as the Disinherited, who held out there against Henry III, were finally defeated.

Castlehythe or Castelhythe.

# Cathedral

Ely's cathedral is one of the great glories of world architecture, and because of its position on a modest hill surrounded by flat fenland – much of it below sea level – it can be seen for miles around. As the fenland around Ely was once flooded with marsh and swamp, the cathedral gained the sobriquet 'the ship of the fens'.

There was a religious settlement at Ely from AD 673 and a substantial abbey building from 970 but work on the cathedral began under Abbot Simeon's direction in 1081 as a symbol of Norman power and authority. The most remarkable aspect of constructing such a building on the island of Ely is that there is no local suitable building stone. All the main building stone had to be brought by water from the quarries at Barnack near Peterborough.

The initial cruciform shape was enhanced by Bishop Northwold (1229–58), who added the magnificent six-bay presbytery and, of course, Alan of Walsingham constructed the lantern tower in the fourteenth century after the collapse of the central Norman tower. There were other setbacks when the north-west transept collapsed sometime at the end of the fifteenth century and during the seventeenth-century Commonwealth the whole building was threatened with demolition, but survived, while in the nineteenth century a major restoration was needed to save it.

Today it stands as one of the longest cathedrals in the world and one of its greatest, but more importantly it is at the heart of the city, not just for worship but as a glorious centre for events of all kind.

'The Ship of the Fens' from Queen Adelaide Way.

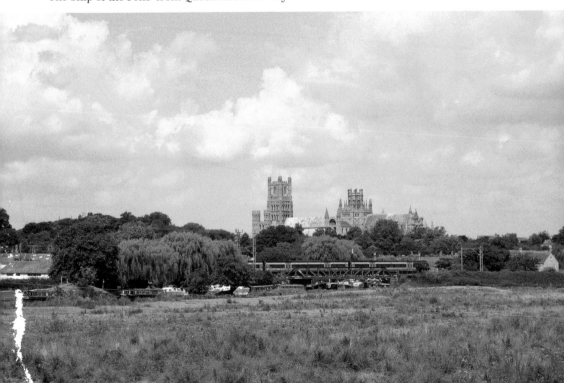

# Cattle Market

For over 100 years the city had a cattle market running in conjunction with the Thursday general market. The cattle market in the area now taken by the Waitrose car park was opened in 1846 under the control of the Ely Fairs and Cattle Market and Corn Exchange Company, with 'over 200 cattle and capital displays of horses, sheep and pigs,' at the first sale day.

Two firms ran the auction markets in the twentieth century: Messrs Grain and Messrs Comins, each with their own sale rings and premises.

The cattle market was popular with farmers and local people but in 1976 there was an outbreak of swine vesicular disease and the restrictions on the movement of animals forced a temporary closure. Many pig farmers went out of business and by the time that the restrictions were lifted it was no longer economical to run pig sales. Comins ended livestock sales in 1979 and Grains in 1981, while the sale rings were taken over by dead stock.

The two firms amalgamated in 1987, but by then East Cambridgeshire District Council, who owned the site, was developing plans to expand the city's retail centre. The final auction of furniture and other miscellaneous items took place on 25 October 1990 and the site was incorporated into the new Cloisters Shopping Centre.

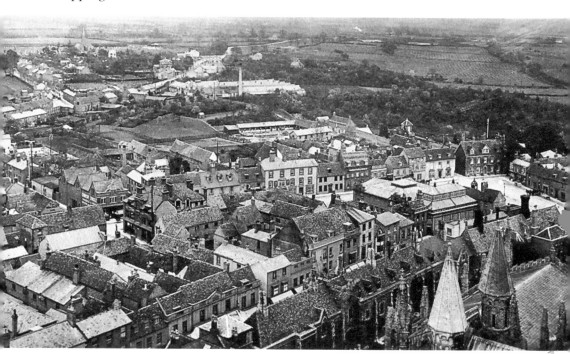

View from the cathedral of Ely centre around 1912, showing the cattle market behind the White Hart Inn with the new jam factory behind it.

# Cemetery

Ely suffered a serious outbreak of cholera in 1832. The city's water supply was notably bad with many people drawing water from the River Ouse, into which the town's sewage and filth ran untreated.

The churchyards of the two parishes of Holy Trinity and St Mary's were already becoming full and with sixty more deaths from the illness the situation became critical. One of the first tasks of the new Board of Health established in 1850 was to find a new cemetery.

Six acres of land on the edge of the New Barns estate were purchased. J. P. Pritchett Jr of Darlington designed the two chapels – one for the Church of England and one for Nonconformists – and the gatekeeper's house. Ely builder Richard Freeman, responsible for many fine buildings in the city and a member of the Board of Health, built them, and the cemetery was opened on 12 May 1855. Once the cemetery was open, then the churchyards of St Mary's and Holy Trinity were closed for burials.

The cemetery was soon extended by the purchase of Mill Close, which accounts for the old mill mound in the grounds.

Today it is beautifully maintained by the city council and remains a classic example of a Victorian cemetery.

Cemetery. The chapel is from the oldest burial area.

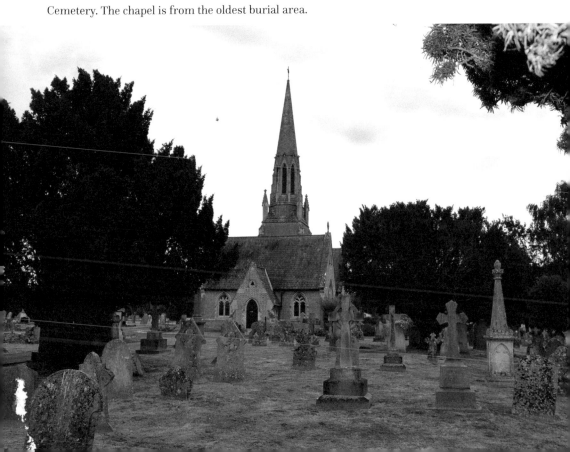

# Chantry, The

The Chantry is a fine private town house set back behind a high wall, with grand wrought-iron gates, alongside Palace Green. Dating from the eighteenth century, it has been the home to some of the wealthiest Ely families, as well as serving during the Second World War as a children's home.

The unusual name is because it was built on the site of a chantry founded in 1250 by Bishop Hugh de Northwold on the green in front of the cathedral. Until the nineteenth century there was little building on the southern side of St Mary's Street, which was largely open. The bishop provided income for four chaplains to 'pray for his Soul and the Souls of King Henry and Queen Eleanor, their children, and the souls of the Bishops and monks of Ely and their benefactors'.

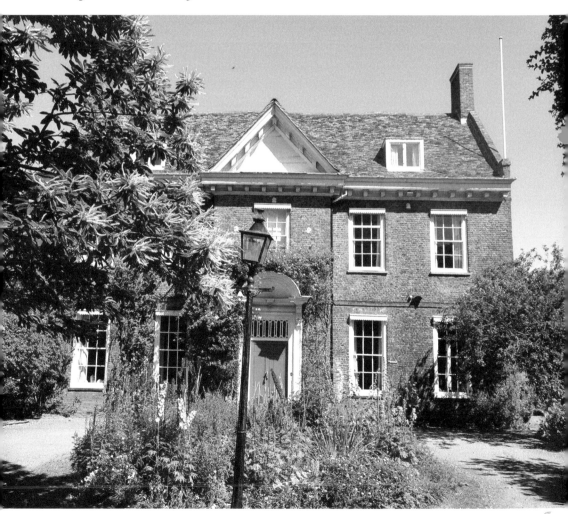

The Chantry.

View from lower part of Cherry Hill.

# Cherry Hill

Cherry Hill in the park is the old motte or mound of the wooden Norman castle, the earthworks of which can be clearly seen. The castle was there for perhaps around 150 years and after it was dismantled a windmill stood on the mound, which adjoins the monastic barn.

As mentioned when writing about James Bentham, he was responsible for remodelling the mound as part of the commemoration of his seventieth birthday in 1779. He removed the windmill, raised the height of the mound with soil from Holy Trinity churchyard, which needed to be lowered, created a new path and planted trees. On the top he placed a summerhouse and erected a pseudo classical column with the inscription: 'That these might benefit another age'. Bentham named the mound Cherry Hill. Ely was famous for its cherry orchards and generally for market gardens, but the cherries were special and there were orchards particularly north of the Market Place, north of Nutholt Lane, at New Barns and off the Prickwillow Road. Ely had a 'Cherry Sunday' to give thanks for a good harvest and good fortune of having earned some extra money for the pickers.

Sadly the monument was vandalised some hundred years later, restored by the Ely Society in 1985, but then vandalised again and removed. As a result Cherry Hill remains fenced off from the public.

# Chettisham

Chettisham is a hamlet to the north of Ely. It is notable for its small Early English chapel of ease, which was heavily restored by the Victorians. Once Chettisham

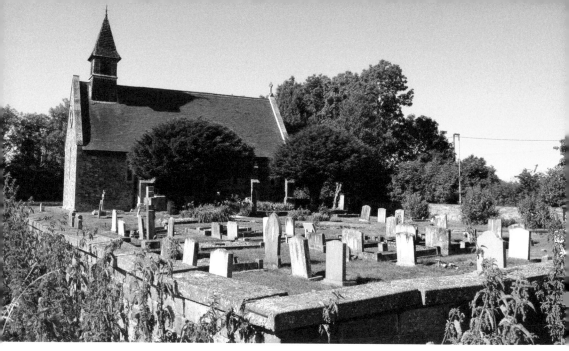

St Michael's, Chettisham.

had a small station on the Ely to March railway line, which was cut through in 1847 between the large farmhouse of the Layton family, at Woodhouse, and the hamlet. William Layton was a big supporter of the railway. Now trains just speed through as they cross the old A10. In 1880 a school was built to accommodate thirty pupils, and was subsequently extended to hold forty-eight in 1897, but closed in 1934, when the building was converted for residential use. The A10 by-pass for Ely passes behind the village, cutting across an ancient walk that leads to Little Downham.

Chettisham has a busy business park and another industrial area around a tall grain retention store next to the railway line.

# Cloisters, The

The Cloisters was the name suggested by a member of the public for the new retail development on the site of the former White Hart public house and Club Hotel yards and cattle market. It was officially opened in November 1999, although most of the shops had yet to open, except for Waitrose, which had been built at the bottom with its car park in 1992.

The Market Place entrance had meant the demolition of the 1966 post office building, which with its plain appearance and flat roof had done nothing to complement the surrounding ancient buildings on the Market Place.

The new development provides a modern public library on the first floor to replace the one built at Minster Place in 1966, which had become too small and inconvenient with its number of steps and staircases.

The Cloisters.

# College, The

Some cathedrals call the area around them, where there are perhaps chapels and the homes of the clergy, 'Closes', but in Ely the area is known as The College. The College boundary to the north is the southern side of High Street, then the Market Place and Fore Hill before being bounded by Broad Street and Fore Hill and the Gallery.

Within The College are old monastic buildings occupied by King's Ely, Prior Crauden's Chapel, and the homes and offices of the bishop, the dean and various clergy.

The College.

The Common.

# Common, The

The Common, alongside Prickwillow Road and the Roswell Pits, is a popular open space, particularly for dog walkers. Until well into the twentieth century Prickwillow Road was known as Common Road. In fact there are two commons, with the one nearest Ely known as Milking Hill Common and managed by the district council, while the lower common is owned by Jalsea Marina, having been sold by Thomas Parsons Charity that owned both.

At one time football was played on the Common and Ely's first attempt at a golf course was on the Commons, which must have been larger, but now with housing all along one side of Prickwillow Road, only the important strip left today is available for casual recreation.

# Corn Exchange and Public Room

It is now thirty-five years since the old Corn Exchange and Public Room on the Market Place at Ely were demolished. Many local people looked on with sadness as the much loved buildings were reduced to rubble, but they had been promised a new building and shops, which would revitalise the city centre.

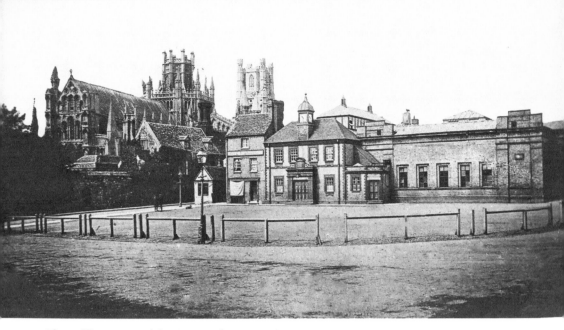

The Public Room and the Corn Exchange, *c.* 1895.

Powerful local farmers and Archer, the Ely solicitors, were the main drivers behind the Corn Exchange Company, seizing on the coming of the railway to Ely in 1845. As the *Cambridge Chronicle* reported in November 1845: 'an Exchange worthy of the wealth and importance of the district built in the centre, would be the greatest improvement that could possibly be made, and render the Market Place the pride of the town, and one of the best in the kingdom.'

The Ely Fairs and Cattle Market and Corn Exchange Company was formed in 1846 and in 1847 the Corn Exchange opened. A poultry market at the rear was not successful and was converted to a reading room in 1855. In around 1890 the reading room was transformed into the public room with an impressive frontage onto the Market Place.

Both buildings were important in Ely's business and social life. The public room was a second cinema for the Rex for many years, finally being known as the Exchange cinema, and the Corn Exchange was used for dances, boxing tournaments and all manner of social events. By the early 1960s, however, the Corn Exchange Company was prepared to sell both buildings. The urban district council was not willing to pay the purchase price and with development companies very active in looking for redevelopment sites in towns up and down the country, the site was sold and redeveloped.

To say that the new 1960s replacement building dismayed many people nationally and locally is an understatement. Iain Nair condemned it as 'The Monster by the Minster'. In recent years several proposals have come forward to redevelop the building and put residential units on top, but these schemes have also attracted opposition.

So what does the future hold? 170 years after the Corn Exchange was built, will Ely again get a building that will be 'the pride of the town'?

Pocket park play area, Country Park.

# Country Park

How many children and families visiting the Country Park, off Cresswells Lane and Willow Walk, and enjoying the space to explore, walk the dog, picnic and use all the play equipment, know that this was once the city's rubbish dump – the common muckhill? Bordered on one side by the ancient Springhead Lane and the other by the railway line, the Country Park is managed by the district council, supported by a willing band of volunteers, and holds a Green Flag Award for the way it is maintained.

The landfill site was full by the end of the 1960s and grassed over. For a while the Ely Society managed it as a pocket park, but the district council took over and in around 2010 footpaths were laid down and play equipment installed and the District Council began its transformation for children's play and general recreation.

Already linked by Springhead Lane to longer walks, the eventual aim is to develop the country park concept right round the western edge of the city.

# Cresswells, The

Ely had watercress beds by the river and near Springhead Lane. The area of the river north of Commuckill Bridge (because it was next to the Common Muckhill) and following the riverside path towards Queen Adelaide is known as the Cresswells. It is pronounced Creasles, because local people called water cress, water creases.

Today the Cooper's Arms fishing club still has rights along that stretch of the river, although the Cooper's Arms was closed in 1954 and demolished in 1972.

The Cresswells today is a popular walk that links with Springhead Lane and longer walks.

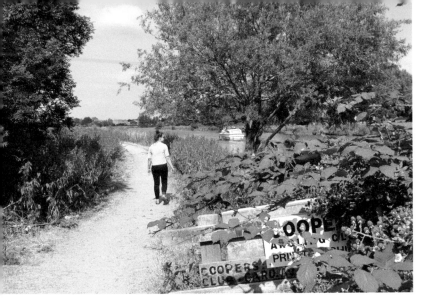

The Cresswells.

# Cross Green

One might say 'Tread softly, for you tread on our ancestors', but few who relax, picnic or play on Cross Green next to the north side of the cathedral know that it was once the churchyard for Holy Trinity parish and the church of Saint Cross, which was built against the side of the nave and there for around 200 years until it was demolished in 1566 and the parishioners moved to the Lady Chapel.

Cross Green, with Helaine Blumenfeld sculpture, July 2018.

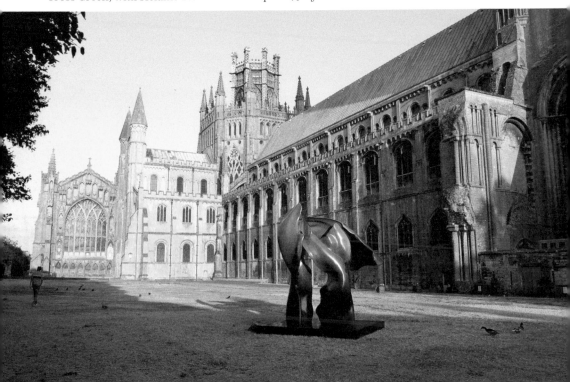

In 1962 the former graveyard, which had seen no interments since 1855, was cleared of its stones and became 'a garden of rest'. A small area to the east end was retained for the interment of ashes of those with close connections to the cathedral, but the rest is a fine open space, which is popular for hosting cathedral events.

# Cuckoo Bridge

The present Cuckoo Bridge dates from 2000 and was officially opened in January 2001. There were two earlier wooden bridges, which replaced an ancient stone bridge that had to be demolished in 1939/40 when it was struck by a barge. The bridge was along the ancient Springhead Lane or Blithinghale Lane, which led to Turbotsey, the ancient port for Ely.

The bridge was needed when Roswell Pits were excavated for Kimmeridge Clay, or gault as it is known, to make river banks to contain the rivers and main drains after the mid-seventeenth century drainage of the Fens. These drainage schemes exposed the fenland peat, which shrank as the water was taken from it and sank as it dried out, leaving the waterways in need of embankment or the fens to be flooded again. This would date the bridge at around 1660, a date put forward by Col Archer in *Old Ely*.

There was a pub, the Pike and Eel, in the vicinity and some old cottages, but nearly everything disappeared when the beet sugar factory was built in 1925.

Cuckoo Bridge.

# Cutter, The

Ely's last riverside public house, the Cutter, is one of its best known and most popular. It owes its origins and its name to when the new cut of the Ouse was made north of Ely between 1827 and 1830. The navvies who worked in their hundreds on the new cut were known as cutters. Sensing the increase in riverside trade, two cottages were converted at the bottom of the land of the public house on Broad Street, which then became the Cutter Tap.

The new cut of the Ouse removed the stretch of river out to where Prickwillow is now. This was a stretch notorious for barges becoming grounded on gravel hards. So the new cut provided a straight route for quite large boats and barges to Littleport and on to Kings Lynn. It also helped to drain the fen around Padnal and allow that to be cultivated.

There was once on an old brewery owned by the Steward family next to the cottages. Whereas once the Cutter was only accessible from Annesdale, the riverside walk begun in the 1960s now takes walkers to and from it beside the river.

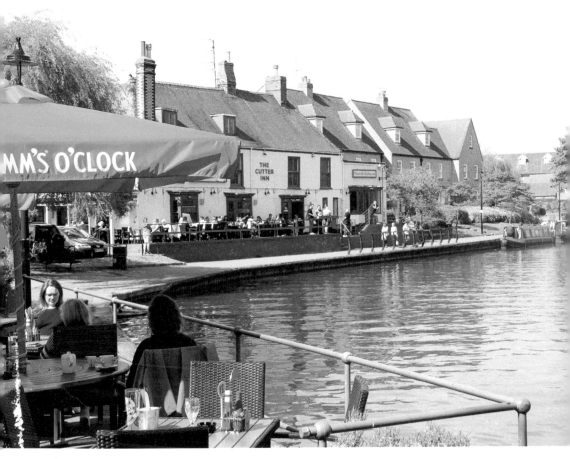

The Cutter.

# D

## Dispensary

This building in St Mary's Street, opened in 1865, carries the inscription 'Heal the Sick'. It was built on land owned by Dr John Muriel, the surgeon, who bought the Chantry and the land on St Mary's Street from the Waddington family in 1846. He also built Cathedral House next to it for his son. Dr Muriel was one of the first members of Public Health Board elected in 1850, whose task was to clean up the city by providing clean water and sewerage and to improve the health of the citizens, so the Dispensary for many who could not afford doctors was another important advancement.

The Ely and District Nursing Association founded in 1886 became based at the Dispensary. There is a plaque on the wall commemorating Nurse Clarke, who served the people of Ely from 1907 to 1939, recording her remarkable dedication as District Nurse and as the British Red Cross Commandant in Ely during the Second World War.

After the health centre was built in Chapel Street in 1970, the Dispensary has had a number of uses, principally as a meeting place.

The Dispensary.

# Eels

There are different theories as to why Ely is so called. The most widely held is that of the Venerable Bede, who lived from around 672–735 and attributed the name to Elge, meaning Isle of Eels. Certainly eels played a huge part in the economy of the Fenland island.

Eels were caught in vast numbers all around the swamps, marshes, lakes and rivers of the Fens. They were speared by glaives or gleaves, trapped in eel griggs or hives (long willow woven baited traps) and caught in nets. They were used as currency and food. Stone for building the cathedral was paid for in eels and they were taken alive from the Fens, especially after the railway made transporting them to London easier, where jellied eels were very popular, particularly in the East End.

Eel Day Parade, 2018.

Eels also formed a great part of the mythology of the Fens and were used in various cures. Eel blood rubbed on warts could cure them, deafness cured by dropping oil from an eel's liver into the ear and a wife could cure her man's excessive drinking by putting an eel into his beer and leaving it to die before he drank it.

Eel skins could be fashioned into garters, or yorks, and worn to combat the fenland scourge of the ague, or even made into wedding rings.

Today there are no eel catchers and eels have been so increasingly rare in our waters that special measures have been put in place to try and increase stocks again.

The annual Eel Parade, the Eel Trail and various artworks all celebrate the significance of the eel in Ely's history.

## Ely College

Ely College is the fully comprehensive school in the city with an adjoining Bishop Laney Sixth Form Centre. The college was formed in 1972, bringing together the former Needham's School and Ely High School at the Downham Road site.

The college, which has over 1,300 students, was taken over by the Cambridge Meridian Academies Trust in September 2016, when it was extensively remodelled with new houses and a new uniform.

The original sixth form centre was also relaunched, taking its name from Bishop Benjamin Laney (1667–75), who left a bequest into a trust for educational purposes.

Students of Ely College in uniform welcome exchange students from the Tyrol, June 2018.

# Ely High School

Ely High School opened in Bedford House on 18 May 1905 under Headmistress Miss E. E. Fletcher, BA. At the same time Miss Piggott's private preparatory school was incorporated into the new school, giving a school roll of around forty-two children aged from six to nearly fifteen, with some boys in the preparatory section.

In 1907 the school, which had seventy-seven pupils by this time, was formally recognised by the Board of Education as a public (which actually means fee paying) secondary school, because a fee had to be paid and the school drew its pupils from the more prominent and wealthy families in the city and the area around.

Miss Fletcher was succeeded by Miss E. M Verini until 1936, then Dr Bertha Tilly until 1966. One of the greatest challenges the school faced was in 1939 when the Central Foundation Girls' School was evacuated from the East End of London to Ely. Miss Tilly shared her house with Miss Dorothy Menzies, Headmistress of the CFGS, and the girls had to share their premises, with the high school girls having their lessons in the morning and the Central girls in the afternoons. The Central girls also had the use of Archer House, the Club Hotel room and some other premises. The Central girls left Ely at the end of the summer term in 1943 and the High School, which was growing in numbers to 455, took over Archer House as additional temporary accommodation.

Bedford House, home of Ely High School, with the high school's badge (inset).

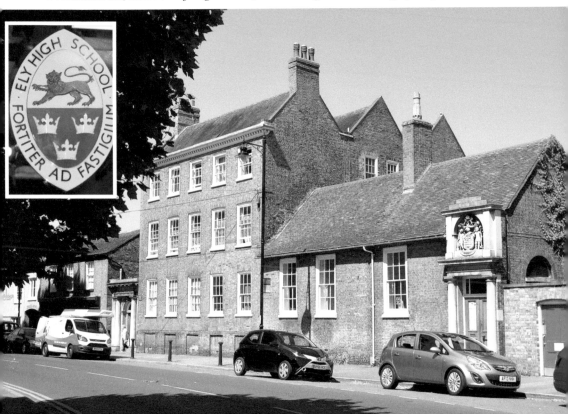

In 1948 the preparatory section, which was open to boys and girls, closed. However, pressure on space was always a problem for the school, which simply outgrew the Bedford House site and in 1957 Ely High School opened in new premises on Downham Road. A new badge and motto, '*Fortiter ad Fastigium*', translated as 'Bravely to the top', inspired by the conquest of Everest in 1953, was adopted at the time of the move. In 1966, Miss Eileen Moody became headmistress after Dr Tilly's retirement, but six years later in 1972 under the comprehensive reorganisation of schools in Cambridgeshire, the High School became part of the new City of Ely College. After sixty-seven years, when the school ventured on in the words of Miss Verini's school hymn 'In Joyful Steadfastness', Ely High School was no more.

# Etheldreda, St

The story of Etheldreda has been wonderfully embroidered by myth and legend, but it is the foundation of her abbey in 673 on the island of Ely that is the origin of Ely.

Ethedreda was one of the four daughters of Anna, the Christian king of the Angles, who had a palace at Exning. To consolidate his fenland border against Penda, the heathen king of the Mercians, Anne arranged for Etheldreda to marry the young Tonbert, a prince of the Girvii, in 652. Part of the marriage settlement was the gift of the island of Ely. Anna was killed in 654 and Tonbert died the next year. Etheldreda lived on the island but she was again married, this time to Egfrith, heir to the kingdom of Bernicia in Northumbria. She would have been about thirty and he was fifteen.

Etheldreda, though, was determined to lead a religious life and she duly fled from her husband and established her monastery.

Etheldreda died on 23 June 679. The exact site of her early monastery is unknown, but it was destroyed in 870 by Viking raiders, who plundered deep into the flooded fenlands and destroyed many religious settlements and the villages around them. The monastery was re-established in 970 by Ethelwold with a new charter by King Edgar. It was close to the site of his monastery that the Normans built their great cathedral towards the end of the eleventh century and Ely became a centre of worship and pilgrimage to honour St Etheldreda.

St Etheldreda depicted on the mayoral chain of the city of Ely.

# F

## Fairs

To be granted a fair charter, which would bring merchants for many miles away, was a huge boost to any town's economy. It was Bishop Harvey, the first Bishop of Ely when a new see was established at Ely in 1109, removing it from the see of Lincoln, who was granted the first fair charter for a three-day fair linked to the vigil of St John the Baptist, which was 23 June, coinciding with the feast of St Etheldreda, founder of the abbey in 673.

A charter from 1318 during the reign of Edward II granted a fair lasting twenty-two days from the vigil of the feast of Ascentiontide. It seems that the earlier fair was moved to coincide with the feast of the translation of St Etheldreda, which was on 17 October. For centuries the Ascentiontide Fair was known as the 'new' fair. The bishop had the grant of these two fairs, while the prior in 1312 had the grant of a fifteen-day fair around the feast of St Lambert, which was on 17 September.

Mayor Henry Constable at the opening of the October fair in Market Place, 1978.

These fairs traded in a remarkable range of goods. There were spices from the East – nutmegs, ginger, pepper, and there was sugar and currants, figs, dates and saffron. Incense came from the East, wax and tallow from Poland, imported through the Hanseatic port of Lubeck to Lynn. The sacrist bought furs and striped material to clothe his servants. Timber was imported from Scandinavia.

Towards the middle of the nineteenth century there were two fairs, one in May and October, and they caused problems with unruly behaviour, too much drinking and criminals taking advantage of the locals. They also went on for too long and it was a relief to many when, what were mainly fun fairs, were restricted to three days each in 1874.

Today Ely has no annual fairs in the ancient tradition: the October fair was last held in 1998 and the May fair in 2014.

# Floods

'The floods are out!' was the local cry when the waters from the River Ouse overflowed into the Annesdale area and Waterside, which happened fairly regularly up until around fifty years ago.

Life in the Fens is all about managing water with so much land below sea level. When there is too much water it is being pumped out into the main drains and rivers down to Denver Sluice, which can release it into the sea. When the weather is too dry then water is extracted from the drains and river to irrigate the crops.

The Bedford rivers were designed with a washland between them to hold the surplus water – the Ouse has washland for sections of it to allow the river to overflow. For centuries after the seventeenth century main drainage there were frequent floods,

Floods at Ely, August 1912. (Photograph by Tom Bolton)

but rivers were straightened, banks raised and wind pumps installed, replaced in the nineteenth century by steam pumps, and today diesel and electric pumps to raise the water from the drains into the main channels.

In 1947, there was a disastrous fenland flood, but a relief channel was cut taking water from Denver to near Kings Lynn. Other major works have kept the Fens and Ely flood free, but without constant investment and vigilance, as sea levels rise, the Fens could once more be underwater.

# Football

Ely City FC is the oldest senior side in Cambridgeshire, tracing its history back to 1885. 'The Robins', as they are traditionally known because of their red shirts (or maybe because they are territorial and aggressive!), now play in the semi-professional Thurlow Nunn League Premier Division at the recently renamed Ellgia Ground at Ely's new Leisure Village.

The original club was formed from members of the Ely St Etheldreda and Cricket Club. They played at first on land at the top of the Common next to the cemetery and then on a field off Station Road at the bottom of Barton Fields. There were simple wooden goal posts and no nets and the players were local clergy, solicitors, business men and trades people. The season ran from October until the end of March.

In the mid-1890s the club found a permanent home on the Paradise, which was shared with the cricket club and the annual August bank holiday sports. As the football season extended the club tried various other grounds to accommodate the fixtures.

Eventually the need to have floodlights and to comply with all the regulations to play at a higher level of football took the club to the Unwin field in 1986 off the Downham Road, where the present sides continue to battle it out with teams from all over East Anglia.

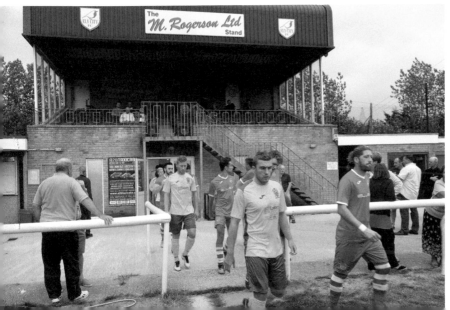

The Robins, 2018.

# G

## Gasworks

Town houses now stand on the site of Ely's gasworks. Twenty-two years after London saw its first gaslit streets, Ely was also marvelling at the new invention on some of its principle streets. In 1835 work began on the building of a new gasworks between the Angel pub and Potters Lane at the foot of Back Hill. The site was close to the river as the coal would come by water. The contractor was George Malam of Lynn and in February 1836 Ely saw its first gaslit streets, with some shops and pubs quick to install their own gaslights.

It could not have been a huge success because in 1840 the gasworks were put up for sale by auction and bought by a London gas company. Ely was not a particularly wealthy town because agricultural wages were so low and the householders and landowners who bore the brunt of the cost of civic improvements were careful with

Station Road Gasworks, *c.* 1920s. (Photograph by Starr & Rignall)

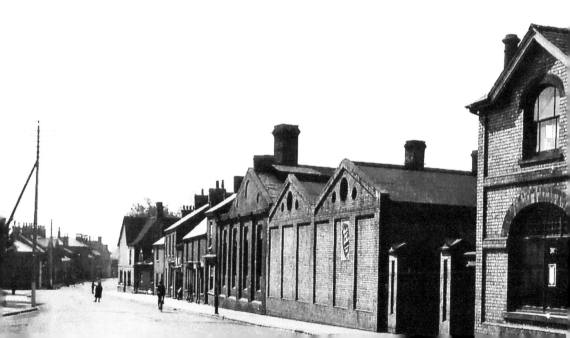

their own money. For years the large works, with its gasholders and from 1926 a tall vertical retort, dominated what by then had become Station Road and the smell of gas pervaded the whole area.

Gas derived from coal remained the main source of street lighting Ely until 1955/56 when electric street lamps were introduced. When the switchover to North Sea Gas for domestic use saw the supply coming from Cambridge, the gasworks was decommissioned in 1959.

After a period of use for part of the site for the Graven's business, then Trigon car showroom, in 1995 the town houses were built there.

# Golf

Ely has a fine eighteen-hole golf course on the Cambridge Road, which was designed by Henry Cotton and opened in July 1973. The golf course was established in 1962 as a nine-hole course by a group of local businessmen and golf enthusiasts, led by Ely solicitor Charles Young. The site of the golf course is on the original Bishops Manor of Barton. Barton Fields, with all its dips and hollows and natural springs, was extensively dug out for gravel when the turnpike road to Cambridge was constructed in 1763.

At the beginning of the Second World War there was a hutted army camp on the site and this then became a prisoner of war camp for Italian and later German prisoners of war. The camp was finally emptied of its last prisoners around 1948 and the huts were used as temporary housing until the whole area was cleared for the golf course.

Golf enthusiasts also have the On Par Golf Course and Driving Range, which was established in 1999 adjacent to the Ely Leisure Village.

Ely golf course.

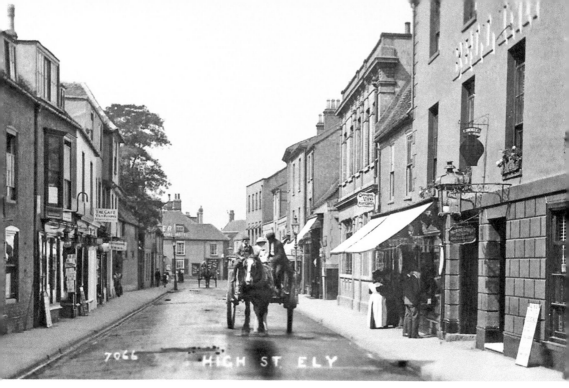

Ely High Street, *c.* 1914, as Elizabeth Goudge would have known it.

# Goudge, Elizabeth

Elizabeth Goudge (1900–84) was a popular and distinguished writer who won the Carnegie Medal for Children's Books in 1946 for her novel *The White Horse*. In around 1911 her father Henry Leighton Goodge became principal of Ely's Theological College and a canon at the cathedral.

Elizabeth loved Ely, for her it was 'the Home of Homes', although when she accompanied her father on his pastoral work to some of the poorer homes in the town, she called the poverty she saw as 'the dark patch upon the beauty of Ely, that creeping evil that invades all lovely things'.

Later, after the family had left Ely, Elizabeth Goudge used the cathedral and The College as the setting for one of her most popular novels, *The Dean's Watch* (1960).

# Grange, The

For many people the Grange is one of the best-known buildings in Ely, but for different reasons. Many will know it as the home of East Cambridgeshire District Council, which it has been since 1975, while others will say that they were born there, as from 1939 until 1974 it was a maternity home, before the maternity unit moved to the RAF hospital in Ely.

The least known part of the Grange's history is its time as a private house. In 1883 Ebenezer William Harlock, the brewer, bought the closed house of correction and the land around it on which to build a private house. The house was built on a substantial scale, perhaps mirroring the Holy Trinity Vicarage, which stood on the other side of Nutholt Lane until it was demolished to provide the site for the new police station in 1970.

It does not seem that the Harlock family actually lived in the house themselves and in 1939 agreement was reached between Mrs Harlock, then living at Quay House, Ely, and Isle of Ely County Council for use of the Grange as a maternity home for expectant evacuated mothers from the East End of London.

Mrs Florence Elizabeth Harlock died in 1948 and in 1950 the Grange was bought by the Ministry of Health and continued as a maternity home. Since purchasing the building in 1975 the district council has added new offices and a council chamber to the old house and extended it substantially along Nutholt Lane.

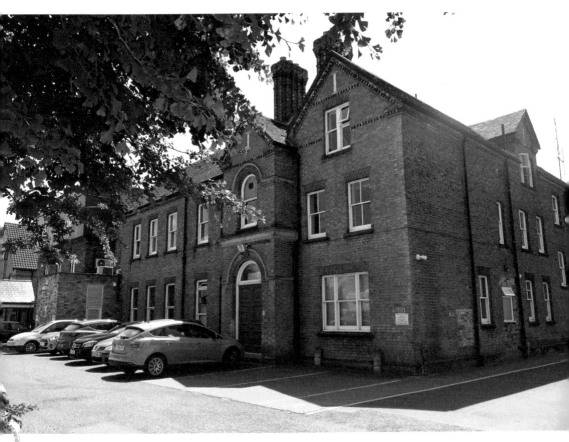

The Grange.

# H

## Hereward

Truly the stuff of myth and legend, Hereward has gone down in history as the man who defended the Isle of Ely as the last stronghold against the invading Normans. In the nineteenth century, with Charles Kingsley's book *Hereward the Wake, Last of the English*, published in 1866, he achieved Robin Hood-like folk-hero status. 'The Wake' was a later addition, seemingly to link him with the Wake family.

Hereward was indeed one of those who gathered on the fenland island to defy the Normans. With him were Danish invaders and after Edgar, the last Saxon claimant to the throne, was defeated by William in 1069, other Saxon rebels including Edwin, Earl of Mercia, Morcar, Earl of Northumbria, Siward Barn and Bishop Aetheleine of Durham.

The natural defences of the old island of Ely.

The island of Ely was self-sufficient in food and there was the monastery with Abbot Thurstan to offer support. Being surrounded by marsh, rivers, bog and reeds, it was easily defensible from direct cavalry attack. William's army laid siege to the isle and legend has it that Abbot Thurstan eventually betrayed the rebels by showing the Normans a secret way onto the island if the monastery was spared retribution. Historians have argued over this secret route, many claiming it was near Aldreth, others possibly near Little Thetford, but the island fell to the William in 1071 and the final resistance was over. The fate of Hereward is unknown.

## High Flyer

The High Flyer public house in Newnham Street dates from 1790 and took its name from one of the most famous racehorses of that time, stabled at High Flyer Hall. At that time there were mainly orchards and open fields between the public house and the hall.

It was Richard Tattersall (1724–96) who bought High Flyer in 1779 and brought the horse to Ely. Tattersall had made a fortune from a horse auction site near Hyde Park in London and in 1783 he bought the lease on land at New Barns, Ely, and High Flyer was put out to stud there where he bred many Derby and Leger winners.

The High Flyer public house and restaurant.

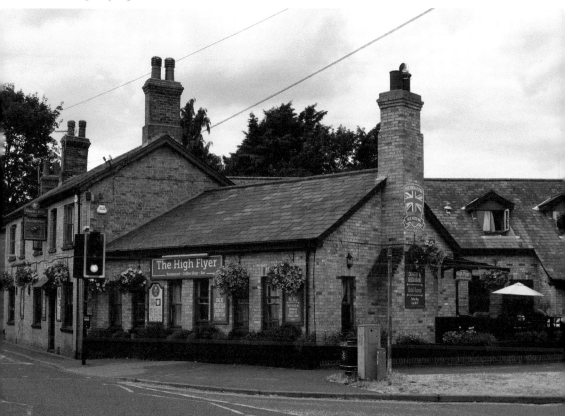

Tattersall built High Flyer Hall as substantial but relatively modest country home and entertained many of the famous figures in horse racing there including the Prince of Wales, later George IV.

High Flyer died in 1793 and a national day of mourning was declared. The great horse was buried in front of the hall.

After Tattersall, known as 'Old Tatt', died, his son, Edmund, known as 'Young Tatt', briefly carried on at Ely but seems to have left by 1802. The stud must have continued there for some years because Napoleon's horse, Marengo, was kept there.

## Hive, The

The Hive is the name chosen for East Cambridgeshire's new leisure centre, which opened at Ely's Leisure Village in 2018. The ageing Paradise Pool opened in 1981 and was on a restricted site, so the decision was taken to build a new swimming pool with associated sports facilities in conjunction with the multiscreen cinema and food outlets and the existing sports users at the Downham Road site.

In addition to the eight-lane, 25-metre main swimming pool, there is a learner pool with a moveable floor, a 140-station fitness suite, two fitness studios, a four-court sports hall and an outdoor 3G artificial grass pitch.

The Hive.

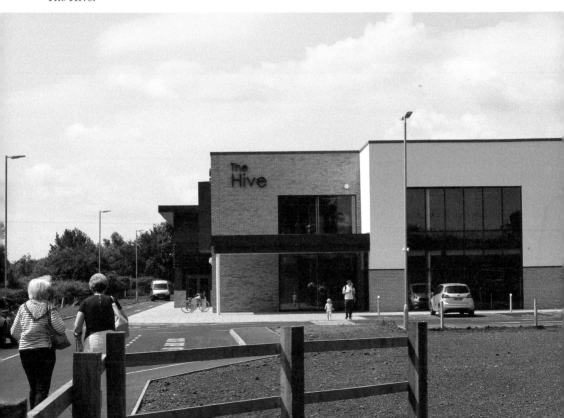

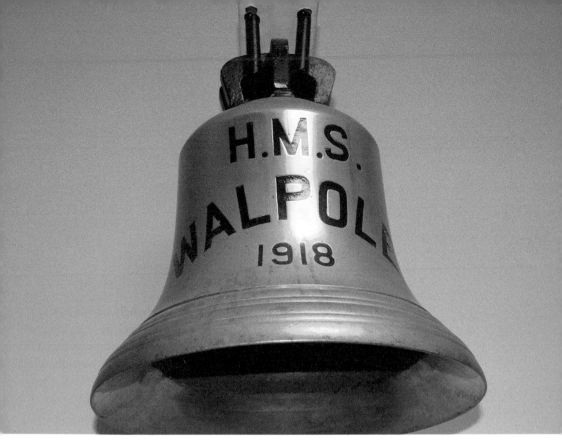

The ship's bell from HMS *Walpole*. (By kind permission of Ely Museum)

# HMS *Walpole*

HMS *Walpole*, an Admiralty V-Class destroyer built in 1918 and the first ship to carry that name, was adopted by the city of Ely after a successful Warship Week National Savings Campaign in March 1942, which raised some £259,000. In December 1943 plaques, with ships motto '*Fari quod aentiaa*' ('Speak as you feel'), were exchanged on the Walpole to mark the adoption.

HMS *Walpole* saw action in the Western Approaches, then escort duties to and from Gibraltar and in the North Sea. In 1942, she was active on escort and patrol duty in the North Sea, but in August and September was at Scapa Flow on anti-submarine duties around Iceland and escorting Russian convoys. In 1944, following a refit at Chatham she was involved in the escort of convoys for the Normandy landings. After the landings she was back in the North Sea and the Channel on convoy escort. At the end of the year *Walpole* was in action against E-boats.

On 6 January 1945 while on anti-E-boats patrols HMS *Walpole* hit and exploded a floating mine abreast of the forward boiler room on the port side. Two of the crew were killed and five seriously injured. The ship was declared a Constructive Total Loss and in February 1945 was sold for breaking up.

For many years after the war, the relationship between former members of the crew and the city was maintained through various visits and reunions. The ship's bell, plaques and other memorabilia are on display in Ely Museum.

# Holmes, Reg

For years Reg Holmes (1902–83) painstakingly researched into Ely's history and typed it up in bound volumes. Reg was active in forming the Ely Society in 1971 and it was through this society and the Local History Publications Group, which was masterminded by Derick Last, that his years of work began to appear in printed form for the public to enjoy and learn more about the city.

He researched into Thomas Parsons Charity, wrote *Cromwell's Ely* (1975), *That Alarming Malady* (1974) about Ely's cholera outbreak of 1832 and the local public houses in *Ely Inns* (1984). He collaborated on old photographic books about Ely, but most of all he was the inspiration to other historians, particularly Pamela Blakeman MBE, and this author.

Reg Holmes in 1973. (Photograph by Nigel Bloxham, courtesy of Pamela Blakeman MBE)

# Iron Bridge

When the beet factory was built the ancient track or tracks that had led from Cuckoo Bridge to Broad Pieces and Queen Adelaide had to be diverted. A new path was routed around the edge of the Beet factory land and ponds and the iron bridge put in place to take the path across the river. This was all done in 1925 long before Queen Adelaide Way was constructed in 1968, so the bridge took walkers on to a riverbank path and drove.

   The iron bridge still provides a vital link on the Fen Rivers Way, but it is not suitable for use by anyone with disabilities because of the steps on both sides.

The Iron Bridge from Queen Adelaide Way.

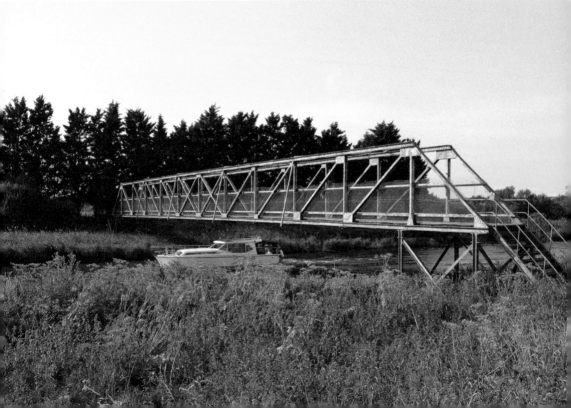

# J

## Jews Free School

Several schools were evacuated from the East End of London to Ely and the surrounding villages on 1 September 1939 on the eve of the Second World War. Ely was deemed a safe area and told to expect 1,980 evacuees, but in the event over the three days, until 3 September, some 747 arrived to be housed in Ely. The majority of these secondary age evacuees came from the Jews Free School, with their Headmaster Dr Enoch Bernstein and the Central Foundation Girls' School, with their Headmistress Miss Dorothy Menzies, both remarkable and seemingly indefatigable leaders.

A number of the evacuees with the JFS were Kindertransport boys who had not been in the country very long at all and needed hostel accommodation. The efforts of Mrs Hinton Knowles, the wife of the vicar of St Mary's Church, and Miss Willink, both prominent members of the Women's Voluntary Service, secured them the use of a large house at No. 37 St Mary's Street, now the site of St Mary's Surgery.

Hereward Hall, the wartime school for the Jews Free School.

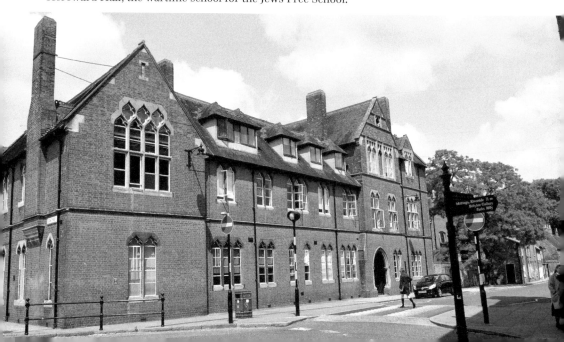

They decorated the house, 'Dug for Victory' in the garden, set up a printing press and produced their own newspapers, made pottery and put on shows and plays for the people of Ely.

Dean Blackburne took a keen interest in the home and the welfare of the boys and it was he who, at one of the lowest moments in the history of the JFS, when the Brick Lane school was destroyed in the Blitz, offered Dr Bernstein the use of the King's Ely's, Hereward Hall, an imposing red-brick building on the corner of The Gallery and Silver Street. From the summer of 1941 JFS had the use of that building.

During their time in Ely evacuees made many friends and the city was sad to see their adopted sons and daughters leave and return to London towards the end of the war.

# John of Wisbech

John of Wisbech is credited with the construction of the cathedral's Lady Chapel, built on the north-east corner because of the monks burial ground at the east end. Work began in 1321 and continued with great difficulty after the collapse of the central Norman tower the next year.

John of Wisbech often ran short of money for his building work and it is said that while digging out foundations a pot of gold was discovered that helped partly fund

The Lady Chapel, with the Helaine Blumenfeld sculpture, July 2018.

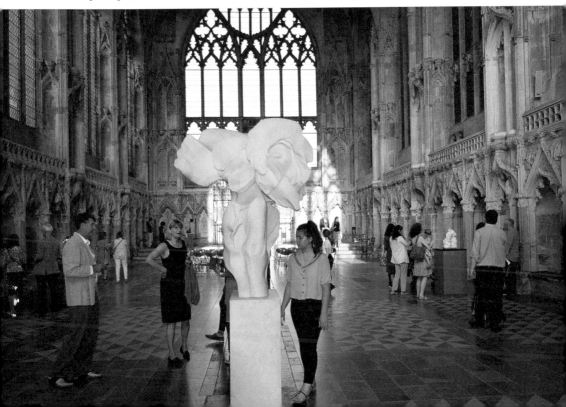

the building work. Progress was slow and it took nearly thirty years to create the wonderful chapel.

In 1348, the Black Death swept the land and even reached the isolated city of Ely, claiming many lives and nearly halving the number of monks from fifty-three to twenty-eight. Among those claimed by the plague was John of Wisbech, who died in 1349, three years before his great work was finally consecrated. The chapel was damaged by iconoclasts during the Reformation and from 1566 to 1936 served as Holy Trinity Church. With its wide unsupported ceiling, the chapel is a glorious light building.

# Jubilee Fountain

To commemorate the Diamond Jubilee of Queen Victoria in 1897, the newly elected urban district council erected a drinking fountain in the corner of the Market Place. It was deemed to be both practical and decorative, but since it was often dry and the attached cups became unattached and disappeared, it was also the subject of ridicule.

As cars began to use the Market Place as the town centre car park in the 1930s, it was also deemed to be in the way, so in 1939 it was moved to be the centrepiece of the green in front of the new bungalows at Archery Crescent. It was unconnected to any water supply and was an ornament rather than for use.

Attempts to restore it to its former place of prominence on the Market Place have all ended in failure.

Jubilee Fountain at Archery Crescent.

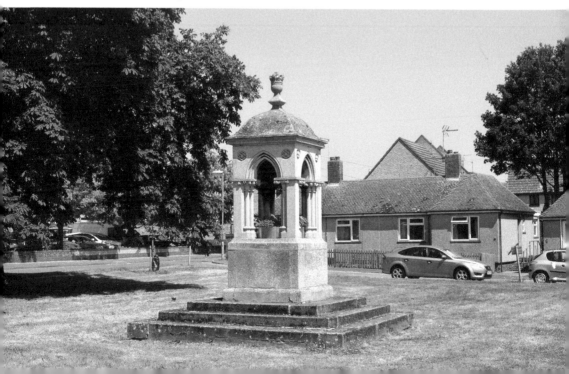

# Jubilee Gardens

Cared for by the Friends of Jubilee Gardens and maintained by the district council, the riverside gardens are a Blue Flag award-winning public open space created by the council and opened by the Duke of Edinburgh in 2002.

The area between Broad Street and the river was Ely's commercial area with wharves and businesses that brought goods in and out by water. There were basketmakers, a coal yard and at one time on this site fell mongers, then more recently a wood yard, first as Alfred Wood & Co, then Jewson's.

The urban district council bought the strip of land along the riverfront in the 1960s and began creating the riverside walk, which by 1968 connected Quayside and Annesdale, thus providing one of Ely's most popular walks.

When Jewson's relocated, the site was cleared and in 2001 the television show *Time Team* broadcast their investigations, revealing that it was a medieval dock and the place where the stone for the building of the cathedral was unloaded before being dragged up the hill through the park area.

The gardens link the riverside walk to the park and cathedral. They also provide various areas for relaxation. There is a sensory garden and a children's play area. There is also a bandstand and in summer the city council sponsors weekly concerts by local bands. The gardens are also busy on Eel Day and the Rotary Clubs' Aquafest, which is held on the first Sunday in July, where there are traditional raft races and other entertainment.

Jubilee Gardens from the river, Aquafest, 2018.

# K

## King's Ely

In March 2012 the ancient King's School became known as King's Ely. There was education by the monks at Ely from 970 but the King's School was refounded by royal charter from Henry VIII in 1541 in the old monastic buildings. It began as a small school for King's scholars, who were all boys.

It stayed a small all-boys school until 1970 when, under the then headmaster, Hubert Ward, it became co-educational. It may well be true to say that since then there has been no looking back, and the school has continued to grow, not just in numbers, but in premises.

On the opposite side of the Gallery on the Palace Field are (since 1970) splendid new facilities including the Hayward Theatre, a new music block, for which the school has an outstanding reputation, and art blocks, while the former Theological College and the whole area of the former Barton Farm are now part of the school.

In 1982, the Acremont House private infants' school became part of King's Ely on the retirement of its founder, Mrs Marion Saunders, and in 1996 Egremont House was purchased for the school, so the school now offers education for around a thousand students, around a quarter boarding. Many students now come from overseas.

Under its current principal, Mrs Sue Freestone, the first female head of the school appointed in 2004, King's Ely is now one of the largest employers in the city and contributes hugely to the cultural, sporting and academic life of Ely and the area around.

Barton Square. King's Ely students are moving between buildings.

# Lamb Hotel

The Lamb Hotel is prominently situated at the top of the High Street and on the old A10. It is the oldest surviving inn in the city, taking its name from *Agnus Dei*, the Lamb of God, and was recorded in Bishop Fordham's survey of 1416.

In the days when cockfighting was a popular sport, the Lamb had its own cockpit.

The major change in its fortunes, bearing in mind its prominent position in the centre of the city on the A10, was when the turnpike roads were constructed and extended in the 1760s and 1770s. Then Ely was connected by roads, the landlord stopped brewing his own beer on site and entered into an agreement with John Harlock to sell his ales. This meant that stables could be built and the Lamb became a coaching inn.

In 1828–29 the Lamb was extensively rebuilt, taking on much of the appearance that it has today, and when the railway arrived in the 1840s, the Lamb sent its own omnibus to and from the station.

Continually improved and changed over the years to meet the demands of visitors to the city, the Lamb remains the city's leading hotel, catering for guests and locals alike in its restaurant and bar.

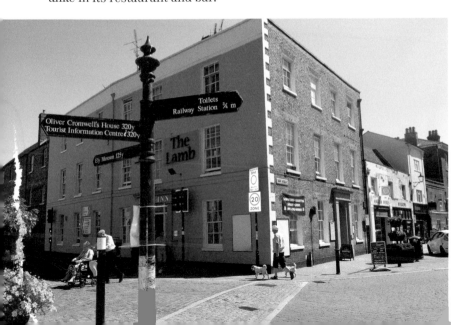

The Lamb Hotel.

Lavender
Green.

# Lavender Green

Lavender Green is a popular informal open space alongside the riverside walk between the Babylon Gallery and Commuckill Bridge. It was originally known as the Grassyards and was linked to the river trade in bringing rushes, reeds and osiers into Ely by water for the nearby basketmakers. When Ely got its first sewerage system it was the site of the first sewage works in the second half of the nineteenth century. Ely's modern sewage works was built nearby in 1958/59.

# Leisure Village

In 1973, during the city's thirteenth centenary celebrations, a new football ground was opened off the Downham Road as a home for the city's Crusaders football club and to relieve pressure on the Paradise Ground. In time the district council bought more land nearby and was able to expand the facilities. Ely Rugby Club, with a clubhouse that included squash courts, and the hockey club moved to the site, joined by the tennis club. Ely City Football Club took over the football pitches in 1986.

The next phase was to extend the leisure concept, and Cineworld opened a new multiscreen cinema complex with adjoining restaurants and food outlets in 2017, including McDonalds, KFC, Costa Coffee and Pizza Hut. Arbuckles, Frankie and Benny's and the Isle of Ely public house are now part of the village.

With the adjoining Hive, the Leisure Village, with its extensive parking, is now a popular destination for a wide range of sporting and leisure activities.

Leisure Village from McDonald's.

# Lincoln Bridge

For centuries Babylon was cut off from the city by the River Ouse after whatever ditches and watercourse were deepened in around 1100. For some years there was a chain ferry at Annesdale, providing access particularly for the boatbuilding business that was owned by the Appleyard family.

In 1964 Harry Lincoln, who had taken over the business, built a new bridge at Waterside to service his boatbuilding factory on Babylon. Sometimes referred to erroneously as Babylon Bridge, it is Lincoln Bridge.

Lincoln Bridge during Aquafest, 2018.

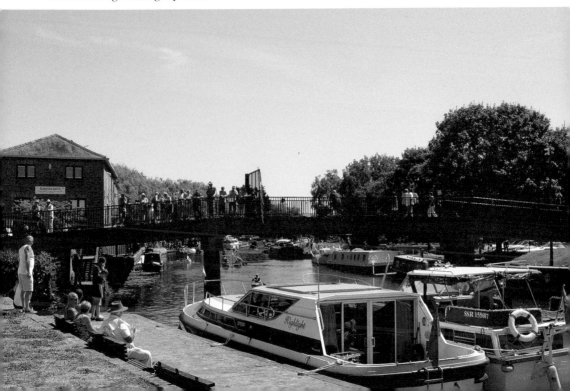

# M

## Majestic Cinema

On August bank holiday Monday 1933 local butcher and businessman Russell Wright opened a new cinema, the Majestic, on the site of his old slaughterhouse. Built by Messrs Tucker & Sons of Ely, it could seat 370 and was fitted with all the latest technology.

In 1937, the cinema was taken over by Owen Cooper Theatres of Suffolk and continued to specialise in double bills of adventure films and popular children's matinees. Towards the end the Second World War the Majestic was popular with prisoners of war in the Ely Cambridge Road Camp and a sign in Italian was put up over the box office. They were given seating on one side and as Leslie Oakey recalled: 'During the newsreels, if an item was shown about the Italian forces, they would cheer loudly, whilst on the other side we young English lads would boo just as loudly. As the war progressed they would join in the English boos each time a German appeared on the screen.'

*Below left*: Majestic cinema opening in 1933.

*Below right*: Bar 62, 2018.

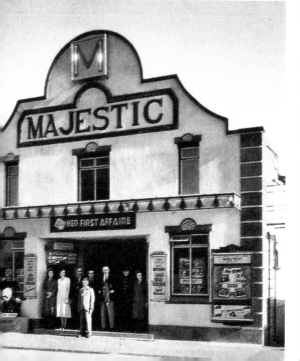

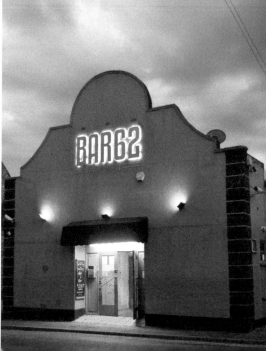

Despite the Sunday opening of the Ely cinemas in 1957, the competition from television and the shortage of action films that the cinema specialised in was too much for the Majestic and it closed very quietly and suddenly in April 1959.

The Majestic always lived up to its billing as the 'Cosy Cinema' and the air was often thick with cigarette smoke, but ushers would walk down the aisle and spray a disinfectant or air freshener about to sweeten it. Despite their efforts the Majestic was known affectionately by its patrons as 'the flea pit'.

Stamford Supply Stores took over the premises and there was then a short period as a bingo hall before in 1984 Brian and Nadine Smith turned it into the 147 Snooker Club, which then evolved into Dean's snooker and social club. The business was put on the market in 2013 and is now Bar 62, a snooker and events venue.

# Maltings, The

Ebenezer William Harlock, the grandson of brewer John Harlock, built the Maltings in 1868, just three years before the Hall family built their new brewery at the foot of Fore Hill and Bull Lane (now Lisle Lane).

When the last Ely brewery at Fore Hill closed, the urban district council was offered the fire-damaged Maltings for £100 if it was converted into a public hall. It was a controversial decision with a local campaign to build a dual-purpose public hall and sports centre on the edge of Paradise proposed as an alternative.

The council, however, went ahead with the conversion with plans drawn up by Ely architect Dennis Adams, which revealed much of the buildings history and clearly showed through retaining the windows the position of the three internal floors that once formed the main hall.

The Maltings was officially opened by the Rt Hon Peter Walker in October 1971 and on 23 November 1973 hosted a lunch for Elizabeth II.

In 1974, the Maltings passed into the ownership of East Cambridgeshire District Council, but in 2015 ownership was returned to the City of Ely Council. The building has undergone many changes in over forty years including the building of a new riverside restaurant, and is at last beginning to perform as Ely's public hall and major events venue as was originally hoped.

The Maltings.

Market Place.

# Market Place

Ely is both a cathedral city and a market town. To have a market charter was important to the economy of any town, especially perhaps one as isolated as Ely.

By the twelfth century the boundaries of the abbey were well defined. The northern side formed one side of Steeple Row, now the High Street, and ran down to form one side of Fore Hill. It may have been that much of the land to the north of this boundary was open, but by the middle of the thirteenth century there were sixteen butchers' stalls in the area, an area now known as Butchers Row. Shops as we know them now did not exist.

Building north of the cathedral was in fairly narrow plots running back towards what is now Market Street, with passage ways, Chequer Lane and High Street Passage, lined up with the Steeple Row Gate and Sacrist's Gate. The old Market Hill, the area now known as the Market Place, not Market Square, remained an open market area. Edmund Carter in *The History of Cambridgeshire* (1749) wrote that market day was on a Saturday where there was 'butchers' meat, butter, cheese, tame fowls, wildfowl and fish of every kind'. The market day was moved to Thursday in 1801. Until 1836 the bishop received the income from the market, but in 1918 the urban district council took over the management and this transferred in 1974 to East Cambridgeshire District Council, who introduced a farmers' market and craft market on Saturdays.

The district council transferred the management to its trading company in 2016 and Ely now has a variety of markets both big and small.

# Marshall, Sybil

There is a plaque placed by Ely Perspective on the fine town house at No. 24 St Mary's Street that is now part of the Poets House Hotel. It commemorates the residence there

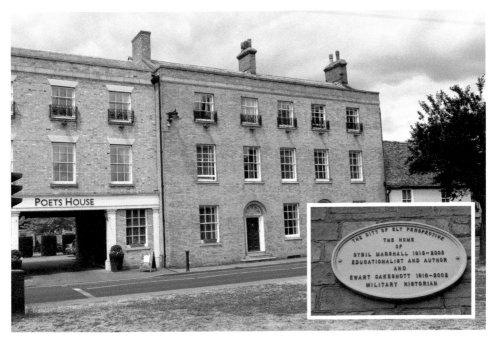

Home of Sybil Marshall (*inset*: Ely Perspective plaque).

of Sybil Marshall and her husband Ewart Oakeshott (1916–2002) a military historian, artist and illustrator.

Sybil Marshall, who died in 2005, was born in Ramsey Heights in 1913 and wrote about her upbringing there in *A Pride of Tigers* (Boydell, 1992). She trained as a teacher and achieved national recognition for her work as an educationalist. Her first book was *An Experiment in Education* (1963). She created 'Picture Box' for the television and wrote the teachers notes.

The story of her parents' lives in *Fenland Chronicle* (1967) is a classic of fenland life. At Ely she wrote *A Nest of Magpies* (1993), *Sharp Through the Hawthorns* (1994) and *Strip the Willow* (1996), three novels about rural life based of her own experiences and people she knew.

She was a guest on *Desert Island Discs*, a winner of the Angel Prize for Literature for *Everyman's Book of English Folk Tales* and received an honorary degree from Sussex University. She was a wonderful raconteur and a source of inspiration to many.

# Military Band

When the militia left Ely in 1908, the band instruments were bought to form a new Ely City Band, which performed under bandmaster Mr J. J. Smith in 1910. For a while after the First World War the band reformed as a Comrades Band – all but one of the old band had served and five had lost their lives. By 1921, however, it was the Ely City Military Band, with

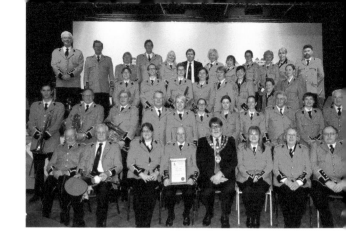

City of Ely Military Band at the presentation of the Freedom of the City to Mr Malcolm Fletcher, December 2017.

Mr J. J. Smith back as bandmaster, but this band came to an end in 1934. It was reformed in 1936 as the Ely British Legion Band, but had folded by the end of the Second World War.

In 1962, a new band was formed with Eric Peters as bandmaster. The band grew in strength and in 1975, under bandmaster Bill Cooper, adopted the red uniforms that are so familiar today. In 1980, Maurice Blake became bandmaster and the reputation of the band spread far beyond Ely including playing at the Lord Mayor's Parade in London.

Since 2004 the bandmaster has been Philip Green and in 2009 in recognition of its services the band was presented with the Freedom of the City, while a further honour was bestowed in 2017 when the long-serving secretary of the band, Malcolm Fletcher, was also honoured with the Freedom of the City.

# Museum

Ely's museum began with a small group of volunteers brought together by local architect Dennis Adams, and opened in the former cathedral choir school at the Sacrist's Gate in 1975. In 1997, local archivist Mike Petty MBE reopened the museum in the renovated and enlarged the former Bishop's Gaol, featuring the old cells and prisoners' graffiti, which is its home today.

Since being at the Bishop's Gaol and with professional curators the museum has grown, achieved accreditation and developed an important education programme. Operating as a trust, the museum now has plans for a major extension and redesign to tell the story of Ely and its relationship to the unique fenland landscape.

Ely Museum open day.

# Needham, Catherine

Catherine Needham, who died in 1730, was a major benefactor of the town. She was the widow of the Revd William Venn Needham, who, as well as being a canon of Ely, acquired an extensive amount of property in Ely including the White Hart Hotel and land behind it, the house of Mr Legge, the brewer on the corner of Market Street and Newnham Street, further land in Nutholt Lane where hemp was grown for rope manufacture at a rope walk in Chapel Street and land at Witchford and Wentworth. On her death she left the bulk of her fortune for establishing and maintaining a school for poor boys in the town.

This was duly built on Back Hill and the building remains today. It opened in 1742 and the twenty-four boys were given a uniform of a hat, rather like a bowler hat, tail coat of green cloth and brass buttons, white corduroy knee breeches, shirt and shoes.

The school eventually became Needham's School for secondary school boys until moving to a new site on Downham Road in 1968. The old school on Fore Hill is now part of King's Ely.

The Needham's Trust is still active and continues to manage land and property and distribute money for the benefit of students in Ely.

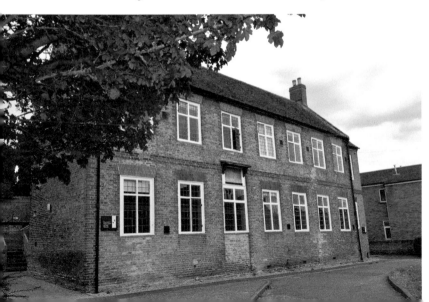

Old Needham's School.

# Nonconformists

In 1774, John Wesley visited Ely and preached 'in a house well filled with plain, loving people'. From a number of different meeting places the congregation grew and in 1818 a new chapel opened in Chapel Street (known as Cats Lane before the arrival of the chapel). This proved too small and Richard Freeman was employed to build a larger chapel facing Chapel Lane with a schoolroom behind, which opened in 1858.

Since then the chapel has been renovated, enlarged and modernised as a modern place of worship and centre for the community, unlike the chapel of the breakaway Primitive Methodists, which was built in Victoria Street in 1847, but became redundant. After a period as a factory has now been totally replaced by modern housing.

With a mission statement of 'Seeking to Worship, Seeking to serve', the Countess Free Church, also in Chapel Street, has a mission in the High Barns area of the city. The church was founded by Selina, Countess of Huntingdon, a follower of John Wesley, and the Ely church was built in 1793. It closed for a short time but reopened in 1802. In the first half of the nineteenth century it grew in strength, so much so that in 1851 it was claiming over 400 worshippers and 200 Sunday scholars, making it 'the largest congregation in the city'.

During the Second World War the building became the synagogue for evacuated Jewish children. It was extensively refurbished in 1985.

There are two former chapels quite close to each other in the centre of Ely. A Salem Chapel built in 1840 in Chequer Lane was used by the Independent Baptists until around 1875. It was then used by the Church of England Working Men's Society and for a while the Liberal Club. After many years as a store it was totally refurbished and opened as a dental practice.

Around the middle of the nineteenth century the Zion Chapel was built in Butcher's Row and this survived until quite recently when it was converted into a private house.

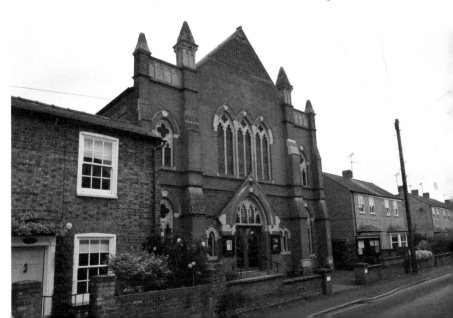

Ely Methodist Church.

# Office of Mayor

Ely was known as a city – it had a cathedral after all – but there was no charter. Ely did not have a corporation and until 1836 the Bishop of Ely exercised considerable secular power.

With the coming of local government, Ely had an urban district council of fifteen members, who were first elected in 1895. The UDC had a chairman who was the civic head.

In 1973, Ely was honoured by a visit from Her Majesty Elizabeth II to mark the city's thirteenth centenary. During this royal visit it was confirmed that Ely had been granted city status.

In 1974, there was major reform of local government. The old Ely UDC was merged with Ely Rural District Council and Newmarket Rural District Council, but not Newmarket town itself, to form East Cambridgeshire District Council. The old Ely

Installation of the mayor, May 2018, with Mr Christopher Parkhouse, Deputy Lord Lieutenant, Graham Smith, bellman and town crier Avril Hayter Smith, Mayoress Cassie Rouse, Mayor Cllr Michael Rouse, Ms Lily Bacon, DL and High Sheriff, and Dr Andrew Harter. (Photograph by Harry Beaumont)

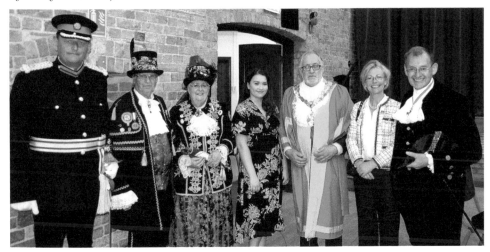

Urban District area became a parish council, but no longer with a chairman, as Ely now had a Mayor, formally addressed as 'The Right Worshipful Mayor of the City of Ely'.

It is customary for the mayor to serve one year in office and combine the role of civic leader with chairman of the parish council.

# Oliver Cromwell's House

For over eighty years the attractive ancient house standing close to St Mary's Church served as its vicarage. When a new vicarage was built in its grounds in 1988 the district council took over its maintenance and management and converted it into a visitor attraction and tourist information centre under the name of its most famous resident.

It was at a low point in Oliver Cromwell's life, having lost his position in Huntingdon and moved to St Ives when he was contemplating emigrating, that he inherited the position of 'Farmer of the Tithes' for the cathedral from his uncle Sir Thomas Steward of Stuntney Hall.

His role was an influential and profitable one, enabling him to live well with his family in the old house, which appears to date from the thirteenth century. It may well have been around this time in the seventeenth century that the house was extended, but parts of the kitchen, where re-enactors demonstrate some of the recipes that Mrs Cromwell used, although much larger then, is very much as she would have known it.

The Cromwell family left Ely in 1647 and moved to London where he became Lord Protector after the execution of Charles I. Jonathan Page, a wealthy Ely man, was the last farmers of the tithes until the role ended in 1836 when the bishop lost his secular power. In 1843, Joseph Rushbrook opened the Cromwell Arms there with a small brewery. Rushbrook put the business up for sale in 1869, but he failed to sell and became bankrupt.

Since 2018 it has been under the control of the city council and is a popular attraction hosting many events, an escape room and a chance to perhaps see some of the ghosts that are reputed to share the old house.

Living history in the kitchen: Oliver Cromwell's House.

## Palace Green

The fine green in front of the west end of the cathedral provides one of the quintessential views of the cathedral and also hosts many popular public events, including an annual food festival and the St Etheldreda's fair. It is the chosen grazing spot for a flock of Ely ducks, which are a popular feature with residents and visitors.

A plaque on the nearby cathedral centre wall recalls a gruesome day in Ely's history when two protestant martyrs, William Wolsey of Upwell and Robert Pygot of Wisbech, having been found guilty of heresy, were burnt at the stake on the green on 16 October 1555, the same day that Bishop Latimer and Bishop Ridley suffered the same fate at Oxford.

In its earliest times it was known as Le Grene and was much larger with only Bishop Hugh de Northwold's chantry standing on it.

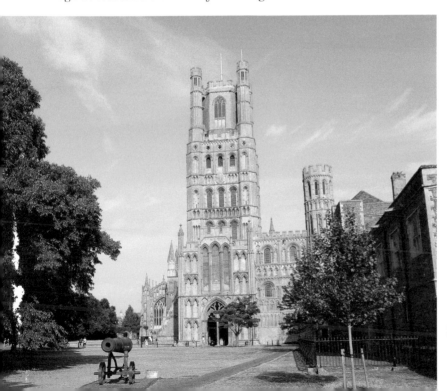

Palace Green.

Paradise.

# Paradise

Paradise, aptly named if it is a pleasant day and your team wins, is the city's oldest sports ground. In around 1855 Ely Cricket Club was given its use and still plays there today.

From 1880 to 1892 Paradise was the venue for an annual sports organised by the Ely Working Men's Club and Institute, which developed into one of the largest and most popular August bank holiday sports events for many miles around. Run by the City of Ely Sports Association, there was a full programme with athletics and cycling and often fireworks at the end or a ball at the Corn Exchange to conclude the day's events. In 1903, some 8,500 spectators were recorded, in 1928 some 9,000 and in 1947, happy the war was finally over, perhaps some 10,000 attended. Numbers, however, began to fall off dramatically in the early 1960s and in 1964 the last sports were held.

In 1929, the ground was enlarged by incorporating the adjoining Priest Bower Close and for many years all the sporting clubs were based there: Ely City Tennis Club, the hockey clubs, Ely City Football Club and the rugby club somehow managing to share the space.

In 1964, the Ely Urban District Council purchased the ground from the Church Commissioners to save it from the threat of development and keep it as a sports ground and open space. Most of the sports clubs moved to new facilities on Downham Road, but it is still used for cricket and football with the Paradise Sports Centre, which opened in 1986, as their changing rooms.

# Park and Dean's Meadow

The Park must be one of the finest urban open spaces in the country, affording a classic view of the southern side of the cathedral. Since 1959 it has been managed by the district council and is open for general use and civic and private parties and concerts.

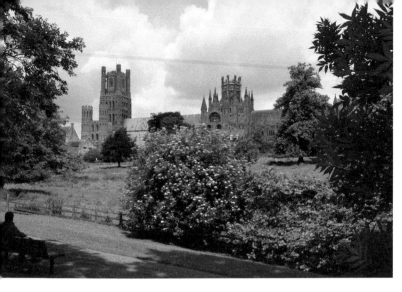

Park and Dean's
Meadow.

The earthworks of the old bailey of the motte-and-bailey castle can be clearly seen, providing irresistible slopes for the young and sometimes old to roll down or sledge down when there is enough snow. For many years the area was part of the monastic grounds and used as a vineyard.

The Dean's Meadow is a private area of the park that provides a rural setting for the one of the great views of the cathedral from the south. It slopes, and is full of dips, hollows and ancient trees. The old hollows were once the fish ponds for the monastery.

Anne Holton-Krayenbuhl, in the fascinating *The Topography of Medieval Ely* (2011), wrote about the ancient water course or common gutter, possibly known as 'Sedgewickes ditch', which seems to have run from just south of St Mary's Church right through the park and across Broad Street and into the river. Looking at the topography of the park and Dean's Meadow it is easy to imagine it today.

# Parsons, Thomas

In the early 1840s George Basevi, one of the leading church architects of his day, designed an open courtyard of almshouses on St Mary's Street for the Thomas Parsons Charity to replace some Broad Street houses, which were in poor repair. This was on the site of Sextry Barn, which had been one of the largest medieval tithe barns in Europe. Sadly Basevi, who also designed the Fitzwilliam Museum in Cambridge, was killed in a tragic fall from scaffolding in the West Tower of Ely Cathedral in 1845, and never saw that scheme completed.

The charity was established in the fifteenth century by a bequest from Thomas Parsons, who left land, tenements and fisheries at Stretham, but despite the late Reg Holmes' extensive research little is known about him.

By the sixteenth century the feoffees of the charity were very powerful in the city, acting like a corporation and combining prominent citizens and cathedral figures. They acquired property and doubtless some of them enriched themselves including Sir Thomas Steward, Oliver Cromwell's uncle, who was a leading member of the charity.

Thomas Parsons
Square.

Two seventeenth-century petitions from Ely citizens brought about an enquiry
and a reform of the charity, which still operates today in providing housing and
supporting the people of Ely.

# Peacock, Dean George

Dean George Peacock (1791–1858) was not only a great figure in the life of the cathedral,
masterminding the Victorian restoration with George Gilbert Scott, but also had a
major impact on the city.

George Peacock was a fellow of Trinity College, Cambridge, and tutor in mathematics.
In 1837 he became Lowndean Professor of Astronomy at Cambridge University. In
1839, having been vicar of Wymewold since 1826, he was appointed Dean of Ely.

Dean George Peacock (By kind permission of the
Revd Mark Bonney, Dean of Ely)

In 1847, at the age of fifty-six, he married Frances Elizabeth Selwyn, the sister of William Selwyn, a canon at the cathedral since 1833. Canon William Selwyn was a keen astronomer, who built his own observatory in The College at Ely.

An ardent reformer, Dean Peacock was concerned about the health of the citizens of Ely and in 1850 became chairman of the first elected Public Board of Health. The Board of Health under his guidance brought a clean water supply to the city, first filtering water from the Ouse then bringing a piped supply from Isleham. Ely's first water tower was built at the top of Cambridge Road. Proper sewers were also installed, instead of the open ditches that were such a health hazard.

Dean Peacock died in 1858 and was buried in the new cemetery that the Board of Health had opened in 1855. His body lies close to that of his brother-in-law, who died in 1875, in an area for the interment of members of the dean and chapter.

# Porta, The

Porta is the Latin word for gate and the Porta is the great gate of the monastery and entrance to The College at the foot of the Gallery off Barton Square.

It was begun by Prior Walpole around 1397 and completed by Prior Poucher in 1417. It is sometimes known as the Walpole Gate and at one time Silver Street was known as Walpole Lane.

Until the Bishop's Gaol opened in Market Street, the bishop had a gaol in the Porta. For many years the buildings has been primarily used by King's Ely, at one time as an assembly hall and theatre, but now the upper floor is the school's library.

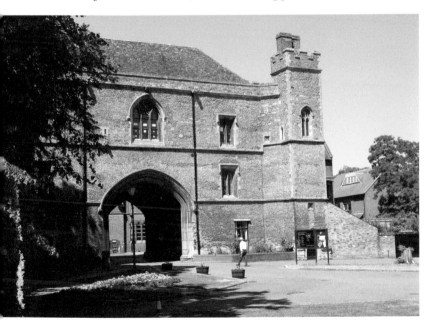

The Porta from The College.

Prickwillow from the drainage museum.

# Prickwillow

Prickwillow, which takes its name from the prickets of willow grown for thatching and basketmaking, grew up along the old riverbed after the course of the River Ouse was moved between 1829 and 1830 and the river straightened north of Ely. The River Lark, which enters the village from the east, flows northwards towards Littleport along the old course.

A school was built in 1862, but was closed in 1983, and St Peter's Church was built in 1866, although there were no interments in the village because of the low-lying nature of the land and the high water table. The church was declared redundant in 2011. A Baptist chapel built in 1875 is still open for worship and the village has a fine modern village hall and the Hiam's Social Club.

Prickwillow is well known for its fascinating drainage museum in the old pumping station next to the Lark, and nearby are the offices of the Ely Group of Internal Drainage Boards, who are responsible for maintaining the drains and watercourses of the low-lying fenland, much of which is below sea level.

# Princess of Wales Hospital

Preparations for the likely war with Germany towards the end of the 1930s identified the need for a hospital in Ely for the Royal Air Force. A site was purchased to the

north of Ely and work began on building, but when war was declared on 3 September 1939 the hospital was still under construction, so the Grange at Littleport, a TUC convalescent home, was used.

The first wards at Ely opened in June 1940. By August the 230-bed hospital was officially operational and named the Royal Air Force General Hospital, Ely. The grounds all around it were used to grow vegetables for the hospital.

In June 1943 more wards opened and the hospital reached a maximum of 527 beds. After the war the number was dramatically reduced to 170 with a further twenty if needed. From 1949 civilian patients were admitted and 'the RAF' became the general hospital for Ely.

In 1977, to recognise its service to the community and the esteem in which it was held locally, the Freedom of the City was conferred on the hospital.

On 9 July 1987 during a visit from Diana, Princess of Wales, the hospital was officially renamed the Princess of Wales Royal Air Force Hospital, Ely.

Sadly in 1992 the Ministry of Defence decided to close the hospital and sell the site for housing. Fortunately the local campaign ACHE (Action Campaign Hospital Ely) saved the core buildings for the Princess of Wales Hospital. Part of the grounds were redeveloped as Baird Lodge, a thirty-five-apartment care home named after Sir John Baird, former commanding officer of the RAF Hospital and later surgeon general of the British Armed Forces from 1997 to 2000.

Princess of Wales Hospital.

While some of the old wards and buildings of the RAF Hospital still remain, it is likely in the near future that the redevelopment of the hospital will see them replaced by new buildings for the medical care of the community.

# Prior Crauden's Chapel

This beautiful small chapel in The College somehow survived many changes of fortune over the centuries. It was built by Prior John Crauden between 1322 and 1328 at a time when the Lady Chapel and the lantern tower were being constructed. Prior Crauden also enlarged his residence, which lay alongside it with a new hall and study.

At the Dissolution of the monastery in 1538 it could have been sold just for the building materials but was converted into a private house. From around 1846 it was restored as much as possible to its original condition. It is likely that the original stained-glass windows had been destroyed during the Reformation, but once restored it was used by King's Ely as a chapel.

In 1986, the chapel was again restored with funding from English Heritage, King's Ely and The Pilgrim Trust. The chapel may be viewed by obtaining a key from the cathedral, but access is difficult as it is by a narrow winding staircase.

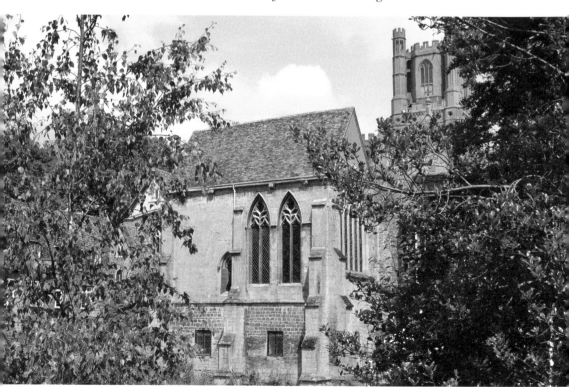

Prior Crauden's Chapel.

# Queen Adelaide

Queen Adelaide is an extraordinary Victorian settlement just outside Ely to the north-east. It grew up in the 1840s when the railways came to the area and a public house was built near the River Ouse, named the Queen Adelaide. Queen Adelaide was Adelaide of Sexe-Meiningen and wife of William IV. The pub has long since gone.

Railway crossings for the Ely to March line, the King's Lynn line and the Norwich line all have to be negotiated along the road from Ely to Prickwillow, which runs through the hamlet, while there is a bridge crossing the Adelaide loop line and another bridge, constructed in 1962, over the River Ouse.

In 1883 a small chapel of ease dedicated to St Etheldreda was built, but was sold for conversion as a private house in 1978, while there was once a small school built in 1872 for fifty pupils and enlarged in 1885, but closed in 1953.

Queen Adelaide has a small village hall and the busy Potters site, once the old beet sugar factory, but mostly it has railway crossings now causing a problem because of the need to upgrade the North Ely junction and allow more frequent trains on the lines.

Queen Adelaide.

# R

## Railway

When Samuel Morton Peto proposed bringing the railway through Ely in 1843, he was supported by the forward-looking Dean George Peacock, local landowner William Layton and other prominent citizens. They could see the benefits in conveying farm produce, grain and cattle from the Fens to wider markets.

Despite the massive engineering difficulties of building across the Fens in 1845 Ely had a station and was soon connected in the next few years, not just with Cambridge, London and Norwich, but March and Peterborough, Kings Lynn, Bury St Edmunds and then St Ives. The St Ives line closed in the 1960s, but Ely is now one of the busiest stations on the rail network, connecting the city with anywhere in the country.

Ely railway station with the *Flying Scotsman* pulling in, 2017.

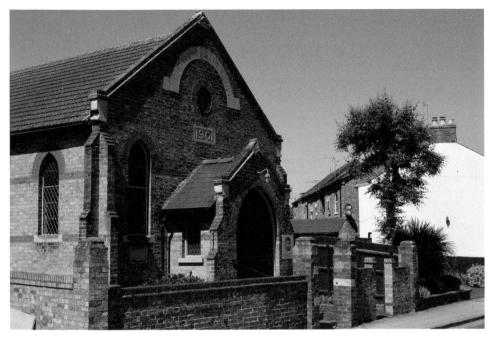

Ely City Church, formerly the Railway Mission.

# Railway Mission

The Railway Mission was built on Silver Street in 1901. The mission had begun in one of the station waiting rooms, then moved to a room in Barton Square before having use of the old Chequer Lane Baptists chapel, which had become the Liberal Hall.

In 1901 work began building the Mission Hall. The internationally famous Christian evangelist Rodney 'Gipsy' Smith attended and led the congregation on his violin in singing 'Onward Christian Soldiers' as the foundation stone was laid.

The building became the home of a charismatic church community, the Olive Tree Fellowship, in 1994 with the Revd Patrick Brandon, and in 2016 under Pastor Billy Onen changed its name to the Ely City Church.

# Ribe

Ely is officially twinned with Ribe in Denmark. Like Ely, Ribe is a cathedral city with a river and again like Ely stands surrounded by flat arable land.

The twinning began in the mid-1960s, through the friendship between long-serving city councillor Colonel John Beckett and the Revd Bitsch-Larsen of Ribe and it is maintained through personal friendships.

Presentation from Ely to
Ribe visitors, 2018.

In 2006, a special tapestry was presented by Ribe. Designed by Ullrich Rosser and woven by Mona Lise Martinussen, it is permanently on display in the foyer of the Maltings with other exchange gifts. Reciprocal visits are arranged and in recent years they have included choirs and rowers, with the guests staying with host families.

In 1975 a delegation from Ely, led by Mayor Sidney Theobald, planted an oak tree in Ribe and in 2015 the Ribe guests planted a tree in Jubilee Gardens to mark fifty years of the relationship. Both trees are healthy and strong, just like the friendship between the two ancient cities.

# River Ouse

When Etheldreda established her monastery on the island of Ely, the nearest point to a large river and for a port was near where the beet sugar factory was built. This was Turbotsey or Turbutsey and it remained Ely's port until the Normans began building the cathedral at the end of the eleventh century. All the stone had to be imported, as there was no suitable building stone on the island. A dock was needed closer to the building site and so the main river that ran at the foot of Stuntney's Hill was diverted into a new channel at the foot of Ely's hill and a landing place created where Jubilee Gardens is today.

For centuries the river was the highway on to the island on which goods were brought in and goods left by. Gangs of fen lighters worked the waterway and larger boats came down from King's Lynn, bringing goods and coal even after the seventeenth-century drainage of the Fens. The coming of the railway, despite building two new docks at Ely, began the decline of water traffic and then the improvement in roads and the ability to move goods by road saw the total ending of river trade in the first half of the twentieth century.

In recent years, however, with the riverside walk begun in the mid-1960s and creation of marinas and gardens, the river is again one of the city's greatest assets and is busy with leisure crafts and rowers.

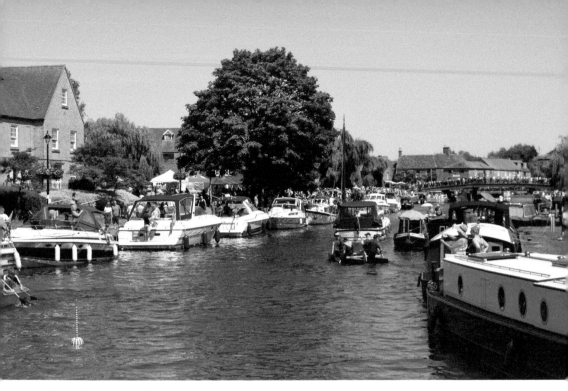

River Ouse at Aquafest, 2018.

# Roswell Pits

Roswell Pits are a beautiful and important wildlife area popular with anglers and since 1946 the home of Ely Sailing Club.

Old maps show various names for the area including Roslyn Hills. The pits were formed over the centuries by excavating the kimmeridge clay, known locally as gault, for building and repairing riverbanks. Barges would work back and forth from the through channel running under Cuckoo Bridge to the River Ouse.

Following the 1947 floods a new pit was dug to the west of the original pits to supply the vast quantities of gault needed for repairs to the broken banks. In the early 1960s part of the original pits, the Blue Lagoon, was filled in after a tragic drowning accident,

Roswell Pits and Ely Sailing Club.

and sometime after that the pits ceased to be used for gault extraction. Since then the pits have become an increasingly rich wildlife habitat. From 2008, and extended in 2009, most of the area, some 210 acres, has been a Site of Special Scientific Interest, because of the important geology that has revealed fossils of much prehistoric life and the significance of the wetland habitat.

# Rugby

The 'Tigers', known for their black and orange kit, had much more recent origins than the football club, being formed in 1950/51, seeing the opportunity to recruit players from King's Ely, which had switched from football to rugby at that time. At first they shared the Paradise Ground alongside the footballers. The changing rooms were old stables and the dash from them, wrapped only in a towel, to and from the shower block in a separate building, was watched with amusement and often a few cheers of encouragement by the hundreds watching the football.

As the club grew in strength and developed more teams, it moved to the Downham Road land after it had been bought by the council in 1973 and built a fine club house with proper changing facilities, an essential bar, a clubhouse and squash courts.

The first XV now compete in the London 3 Eastern Counties League, but there are teams for all ages and conditions.

Ely Tigers Rugby Club, 2015.

# Sacrist's Gate

The Sacrist's Gate connects the old monastic grounds with the High Street, or Steeple Row as it was once known. It is in a range of medieval buildings, now mostly converted into shops, including the Goldsmith's Tower, built in 1325/6 by Alan of Walsingham, probably the most famous sacrist in the history of the cathedral.

From 1858 to 1947 the cathedral choir school occupied part of the range alongside the gate. In 1974 Ely Museum began in the same premises until moving to the Bishop's Gaol in 1997. Octagon Dance Studio now uses the building.

Sacrist's Gate from The College.

St Audrey's Well.

# St Audrey's Well

Many walkers probably pass this small pond on the Barton Fields, now part of King's Ely and close to the golf course, without realising that it has historic connections to St Etheldreda, the founder of the monastery at Ely. St Etheldreda was also known as St Audrey, and this spring and pond are known as St Audrey' Well.

# St Etheldreda's Church

The Roman Catholic Church of Saint Etheldreda in Egremont Street holds a sacred relic of Saint Etheldreda. In 1953 to mark the fiftieth anniversary of the opening the church, Father Guy Pritchard, its much respected priest, received the return of a relic of the left hand of St Etheldreda, which is on view today.

St Etheldreda's Church.

Dedicated by Bishop Riddell to St Etheldreda on 17 October 1903, the feast of Saint Etheldreda's Translation, the present church replaced a corrugated-iron church opened there in 1892 by Father Freeland, who had arrived in Ely in 1890 with £10 and his bishop's blessing to establish a permanent church. Up until then, especially after the arrival of the railway, visiting priests had come from Cambridge to conduct services in private houses.

# St John's Hospital

The substantial remains of the ancient hospitals of St John and Mary Magdalene are contained within a private farm owned by the Runciman family since 1925, but not much is really known about their history.

The Chapel of St Mary Magdalene dates from 1172 and was a leper hospital, while the nearby Chapel of St John the Baptists was founded by the priory around 1200. The two hospitals were united by Bishop Hugh de Northwold in 1240 and placed under the control of the Sacrist of Ely. In Bentham's *History and Antiquities of the Conventual and Cathedral Church of Ely* (1771) he writes, 'The Hospital was to consist of thirteen Chaplains and Brethren, who were to have a common refectory and dormitory and wear a uniform habit.'

After a period as free chapels the buildings were suppressed in 1561 and ownership passed to Clare Hall, Cambridge. At this time the old buildings were largely destroyed, with the stone being used to create the farm and its buildings.

There has been much speculation that an eighth-century stone carving incorporated in a barn on the St John's Road was from St Etheldreda's original abbey, which might have been established somewhere in the vicinity.

Saxon carving on barn at St John's Farm.

St Mary's
Church.

# St Mary's Church

St Mary's Church is a delightful and spacious building. It was one of two parish churches, the other being Holy Trinity. The present church dates from the time of Bishop Eustace (1198–1215) but it is likely that it was a rebuilding of an earlier church.

In the days of the monastery, the sacrist of the cathedral was responsible for its upkeep and the appointment of curates to take the services, although worshippers had to attend the cathedral to hear the sermons. After the dissolution of the monastery in 1538, the dean and chapter nominated the vicar. The south door was once the main entrance, serving the population clustered on the Silver Street side of the building.

The churchyard ceased to be used for burials in 1855 when the new city cemetery was opened. Cleared of its gravestones many years ago, the area around the church is a well-maintained garden of rest. The church was extensively renovated in 1876 when it was reroofed, wooden galleries were removed and new pews installed.

The church has many memorials inside to prominent Ely families including the Waddingtons, Pages, Laytons, Halls and Harlocks, while on the wall outside is a memorial to the five Littleport men hanged at Ely after being convicted following the Ely and Littleport Riots of 1816.

In 1985 an elegant and practical extension was built at the south side, providing a splendid function room with office space and toilets. Currently the church is planning further remodelling to make it suitable for modern worship and community use.

# St Peter's Church

In 1889 Catharine Maria Sparke, the widow of Canon Edward Bowyer Sparke, paid for a mission church in memory of her late husband to be built on Broad Street to

St Peter's
Church.

serve one of the poorest areas of the city, which was then experiencing much growth after the arrival of the railway in 1845. Canon Edward Sparke was the second son of Bowyer Edward Sparke, Bishop of Ely from 1812 to 1836, who was notorious for enriching his own family with church livings.

While St Peter's is plain on the outside and hemmed in by other buildings, it is welcoming on the inside and is remarkable for its highly decorated rood screen, the work of the young Sir John Ninian Comper (1864–1960), who became nationally known for his decorative church furnishings.

# Sessions House

The imposing Sessions House on Lynn Road, owned by the City of Ely Council since 2103, was built at the instigation of Bishop Bowyer Edward Sparke and Edward Christian, Chief Justice of the Isle of Ely, following the Ely and Littleport Riots of 1816. The old sessions house on the Market Place was small and fears that there might be further unrest in rural areas leading even to a French-style revolution called for a show of authority, the result of which was in 1820 a grand new courthouse next to the Bishop's Gaol, which would have a house of correction behind it.

The first major murder trial in the Sessions House was that of John Rolfe, who was found guilty of murdering a fellow poacher probably to rob him of his few possessions. Judge Christian in February 1823 passing sentence declared: 'You are unfit for earth, unworthy of heaven and are sentenced to be hanged by the neck until you are dead.' After the unfortunate Rolfe was hanged his body was covered in pitch, placed in hoops and suspended on a gibbet in Padnal Fen in view of his father's house. For many years he swung there as a grisly warning and gruesome attraction for the curious. The vain Justice Christian died a few weeks later, in, as one of his contemporaries sneered, 'the full vigour of his incapacity'.

The Sessions House,
Christmas 2017.

As well as the main court, which also served as a meeting place, the north wing was the armoury of the 6th Cambridgeshire Rifles, while the south wing served as a chapel for the house of correction before becoming Ely's first police station in 1843, until new premises on the corner of Nutholt Lane and Lynn Road opened in 1970.

The Court Service made the building redundant in 2011 and the city council, responding to public concerns, purchased it for the community for £1.00. Having moved the council offices into the north wing, the council is still developing the building for community use while retaining its important historical features.

# Shippea Hill

Shippea Hill is the furthest extent of the parish of Ely, with a claim to fame of having one of the least-visited railway stations in the country, sometimes the least visited. Nearby was the Railway Tavern, now a private dwelling. It stands in Burnt Fen, which once had a school opened in 1872, eventually closing in 1961. Nearby was the Burnt Fen Institute, opened in 1932 by Sir Fredrick Hiam, local landowner and farmer. This building fell into disrepair some years ago. There was a corrugated-iron church, which opened in 1890 and was dedicated to St James. It remains a scattered community closely linked to farming the land.

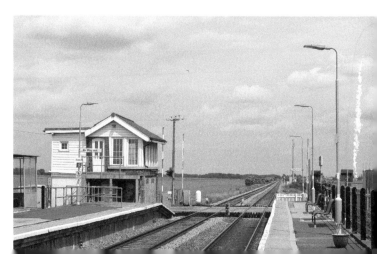

Shippea Hill station.

Springhead Lane.

# Springhead Lane

Taking its name from the springs that occur there, Springhead Lane was once known as Blithinghale Lane and is probably the most ancient track in the city, once leading to and from the Saxon port for Ely at Turbotsey.

Once away from the built up part of the lane it is a delightful country walk with the first stage of the Country Park on one side and Roswell Pits on the other. This part of the lane is known locally as Lovers' Lane, although on some maps it is called Lower Lane. It connects with Kiln Lane, which runs down from Prickwillow Road and refers to the old brick kilns that was once there using clay from nearby, though there are no remains of them today.

# Standen Engineering

Standen Engineering on Station Road is the UK's leading manufacturer and exporter of potato planting and harvesting machinery. Originally the family were iron smelters in Sussex before moving to Pig Lane in St Ives around 1849. They became John Deere dealers and, subsequently, when they began manufacturing sugar beet harvesters they painted them green in the John Deere colour. In 1936 Standens built a new works on Lynn Road Ely.

In 1958, having been where The Paddock housing development is now, the company moved to the new Hereward Factory at Station Road, an occasion that Mr Peter Standen, chairman and managing director of F. A. Standen, declared 'the greatest occasion in our history'.

84

Standen Engineering on Station Road.

# Steeple Gate

Steeple Gate was the entrance from the High Street, once known as Steeple Row, to the churchyard of Holy Trinity and the Church of St Cross. The gate dates back to before 1417 and is built over an earlier undercroft. In 1978 it was restored by local builder John Ambrose as a tearoom.

Holy Trinity was the larger of Ely's two parishes and worshippers used the nave of the cathedral, but with their services being interrupted by those of the monks, the parishioners asked for a church of their own. Eventually during the time of Bishop Langham (1362–66) a lean-to structure dedicated to Saint Cross was built alongside the northern wall of the nave.

Apparently it was poorly ventilated and lit and unpopular with the congregation. It did survive, however, for 200 years until the church was given use of the Lady Chapel in 1566. Holy Trinity stayed in the Lady Chapel until the two parishes were amalgamated in 1937 and there are several memorials to the congregation in the entrance.

In 1962 the old churchyard was cleared of its tombstones and the area was laid out as Cross Green, a popular space for informal leisure or cathedral events.

Steeple Gate from the High Street.

# Stuntney

Stuntney, the name meaning 'steep island', sits on the edge of higher ground looking across the Fens towards Ely. Once the River Ouse ran at its foot and when the fields are bare its course can clearly be seen, but the river was moved to the foot of Ely's hill around 1100.

There was a small Norman church at Stuntney but this was replaced by Holy Cross Church in 1876, which was further rebuilt in 1903. Few traces of the originally Norman church survived, but the small church remains open for worship.

Like most small villages, there was a school, which opened in 1864 close to the church but closed in 1983 and was converted for residential use. The two public houses the Anchor and the Lord of the Manor have long been private residences, but there is a social club.

The village was bypassed in 1986, with the new A142 running between the church and the Old Hall. Stuntney Old Hall, a small Tudor house, was owned by the powerful Steward family in the seventeenth century. Oliver Cromwell's mother was a steward and the death of Thomas, Steward of Stuntney Hall, brought Cromwell to Ely and reversed his declining fortunes in 1636. The hall fell into disrepair but in recent years has undergone a magnificent restoration by local landowners and farmers, the Morbey family, as a hotel and wedding venue.

Stuntney with Holy Cross Church.

# T

## Theological College

Ely's theological college was built on Barton Road on or near the site of the old Bishop's Gaol – Barton Road itself was known as Gaol Lane. The College was founded by Bishop James Woodford, who was Bishop of Ely from 1873 to 1885 and it is his statue that adorns the front.

The College had extensive grounds running along Barton Road and they were often used for garden fêtes and community events. The theological college closed quietly in 1964.

Former theological college.

Bishop Woodford House, the diocese of Ely's retreat and conference centre, was built in 1969 in part of the grounds, while King's Ely now occupies the old college building and the rest of the site, including Barton Farm, which it acquired in 1972.

# Town Crier

For centuries the town crier was how many people heard of events, like the proclaiming of fairs or national news. In the early years of the twentieth century Ely's town crier was Blind Wayman. When James Ankin relinquished the post in 1960, no reappointment was made until 2001, when the City of Ely Council voted to appoint a new town crier. Avril Hayter-Smith duly became Ely's town crier and since then not only has she performed duties in Ely but represented the city at competitions throughout the country. She launched a successful annual town crier competition on Eel Day and in 2018 Ely hosted the British National Championships. To mark her outstanding services to Ely, the city council bestowed on her the Honorary Freedom of the City of Ely.

Ely's Bellman, Graham Smith, with national champion town crier Michael Wood from the East Riding of Yorkshire, and town crier Avril Hayter-Smith at the National Championships, Ely, 2018.

# Union Workhouse

The Poor Law Amendment Act of 1834 brought about the building of a union workhouse in Ely to replace the two parish workhouses that had been responsible since the Poor Law Act of 1815. The new workhouse at the top of Cambridge Road would cater for a union of parishes: Ely, Coveney, Little Downham, Grunty Fen, Haddenham, Wilburton, Littleport, Mepal, Sutton, Wentworth, Witchford, Little Thetford and Stretham.

There was a board of guardians drawn from the parishes and such workhouses were planned around 15 miles apart, the distance a vagrant or 'gentleman of the road' could walk in a day. These visitors were housed separately from the local residents.

The Ely Union Workhouse opened in 1837 and could accommodate 340 people, with men and women kept separately and married couples only allowed to meet at Sunday chapel. The inmates were clothed and fed a basic diet relying heavily on gruel and bread, soup and broth and vegetables with a little meat, but this diet could be supplemented with a little ale for the over sixties if the medical officer thought it would improve their health.

The workhouse was often known as 'the spike', as one of the tasks given to those in there was unpicking oakum on a spike. It would be true to say that many people so feared being taken into the workhouse that they persevered with living in dreadful poverty.

After the National Health Service was introduced in 1948 the workhouse was adapted and it became a care home for the elderly or infirm and renamed the Tower Hospital.

Former Union
Workhouse.

A very active Friends Group raised money for new lounges and facilities. In 1961 the friends revived the Hospital Sunday carnival parade to raise money.

The hospital ceased to be used in 1993, and in 1998 the Springboard Housing Association converted some of the buildings and the chapel into Tower Court residential units.

# Unwin

The 2017/18 season saw Ely City Football Club play at the Ellgia Stadium, changing the name from the Unwin Ground. Ellgia is an Ely recycling and waste firm that now sponsors 'the Robins'. So who was Unwin? In the history of the club, which was founded in 1885, the name Unwin featured for some 100 years. First there was Harry Onion (the name was changed to Unwin in the early 1940s), who was a player from 1902 until the club suspended its activities at the outbreak of the First World War. After the war he served as a club officer as chairman and treasurer for twenty years until he retired in 1948. He was club president at the time of his death in 1957.

His son, Douglas Unwin, was also a player, but better known as the club's chairman and then the club president for over thirty years. He was at the helm when in 1986 the club moved from the Paradise to its new home at Downham Road. The ground was named the Unwin Ground in honour of the service of father and son.

Their dedication to Ely City Football Club was unequalled, but their name was also well known in Ely business from before the 1840s when John Henry Onion established his agricultural woodworking business on Common Road (Prickwillow Road). The Onion family were carpenters, market gardeners, wheelwrights, publicans, and even lightermen in the nineteenth century, but it was the agricultural woodworking business that survived.

For many years Unwins were a feature on Ely Market, displaying their cattle cribs, gates and ladders in front of the Corn Exchange. Goods were dispatched by rail until 1933 when a new delivery lorry was purchased, which opened up the surrounding fenland to them.

By the time that Doug Unwin retired from manufacturing in 1978, the business was centred next to the family home – Roswell – built by his father in 1932, with an industrial estate next to it. The works and the industrial estate were redeveloped as Douglas Court after his death at the age of eighty-five in 1999.

Douglas Unwin (centre) with the delivery lorry, c. 1936. On his right is his younger brother John, killed in action in 1944.

# V

## Valour

During the First World War, as the news of casualties was received in Ely, lists were posted. A temporary City War Shrine was unveiled by the Bishop of Ely alongside the Market Place on June 29 1917, then recording 105 names of the fallen. After the war the permanent shrine was built and unveiled on 30 April 1922, listing 224 names. The full story of the memorial and those recorded on it from 1914 to 1918 is told in Patrick Ashton's *Remembering Ely*, published by Ely History Publications in 2018.

The memorial now records the names of those who fell in the two world wars and serves as a memorial to all those Ely men who have died in other conflicts.

Remembrance Sunday 2017.

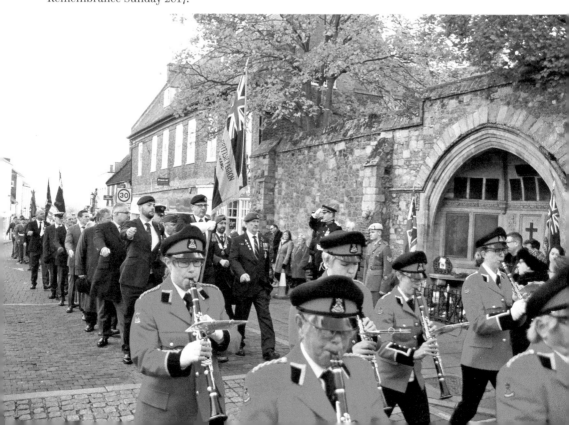

# Waterside and Quayside

At the bottom of Fore Hill the road becomes Waterside, which is flanked by very old cottages and the former Black Bull public house, and then just past the old public house it widens out as it runs down towards the slipway, the river and Quayside.

It is an area full of history and character. This was where goods entered and left the town, where there were breweries and basketmakers' yards, merchants and poor labourers. The wide area served as a fair ground and marketplace at times. Quayside was one of the busiest commercial areas of the Ely. Goods were loaded and unloaded there, fenland lighters operated from the wharf and there is an ancient slipway.

Quayside and slipway, from the river, Aquafest, 2018.

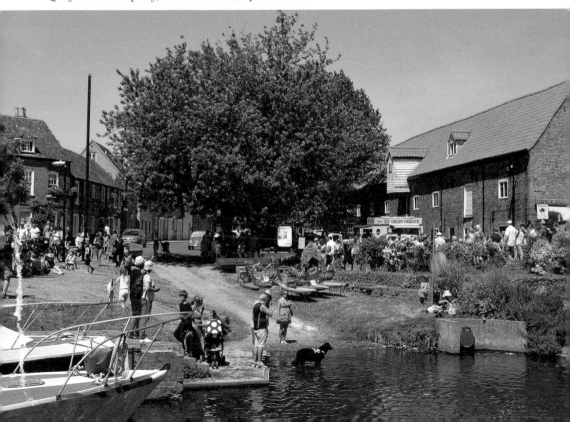

With two breweries, the area was noted for a number of public houses, the oldest, probably dating from the seventeenth century, was the Ship, which stood on the corner of Ship Lane but was demolished in the early 1960s. There was also the Queen's Head, now a private house, the Three Crowns at Crown Point, the Black Bull a few doors above it and the Cooper's Arms nearly opposite.

However, when the river trade ended and there were very few leisure craft on the river, the whole area declined. The breweries had gone, many of the old pubs had closed and some old buildings had been lost. It was the demolition of the Coopers Arms public house and the threat of further 'slum clearance' that led Una Hodson, living then at the former Three Crowns, to instigate the formation of the Ely Society in 1971. This prompted a General Improvement Area order and the saving by restoration of this fascinating part of the city, which along with the conversion of the Maltings into a public hall and the further extension of the riverside walk brought new life back to the Waterside.

Today there are no public houses but there is the award-winning Peacock's tearooms next to Babylon Gallery and the Riverside Bar and Kitchen adjoining the Maltings.

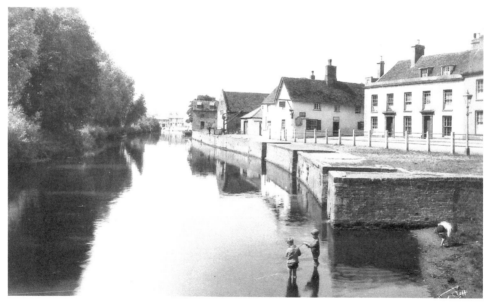

Quayside and the old Ship Inn, *c.* 1930.

# Xenophobia

The isolated nature of the Fens meant that there was always a suspicion of 'furriners' – any strangers coming into the area. Some villages were always 'at war' with their neighbours, chasing them off 'their territory'.

Ely as a market and fair town was always more open than most, but the respectable citizens of Ely were never slow to complain of the rowdy behaviour of those attending the fairs and the undesirable elements they brought into the city. 'Travellers' were banned from entering many public houses.

In recent years, as Ely has grown, there is a far greater tolerance. Many eastern Europeans have found a home in Ely and work in the service and caring industries, while seasonal workers from Europe are essential for harvesting the crops grown in the Fens.

Whereas once fish and chips was the staple takeaway food, now Ely hosts food markets and has a mix of restaurants serving dishes from all around the world, which has all happened in the last fifty or so years.

'Tastes of the World', High Street, May 2018.

# Y

## YEH

The Youth Ely Hub Trust is the brainchild of local councillor and businesswoman Elaine Griffin-Singh. Concerned over the lack of a gathering place for young people in the city following the loss of the old youth service and youth clubs, she seized on the opportunity of leasing the former Cambridge Territorial Army Drill Hall for the community and particularly young people.

Built in 1939, the drill hall on Barton Road had served as Centre E, a county council youth club, and later part of it was used for the education of young people outside normal schools, but those uses had ended and the building was earmarked for demolition.

It is a bold venture supported by a small group of enthusiasts, but the building once again is providing a space for many clubs and a safe space for young people to gather.

Former Territorial Army Drill Hall, now Youth Ely Hub.

# Zanders

Ely's wealth and even existence was based on the eels and fish that were caught in the fenland rivers and meres. Even after the seventeenth-century main drainage, the rivers were harvested for eels and fishing, which for many was a way of putting food on the table. Fishing was not a sport for most people but a livelihood.

So popular were the waters around Ely that either side of the turn of the twentieth century the men from Sheffield would take their wakes week as a fishing holiday in the city and the 'Sheffielders' were welcome in the guest houses and people's homes to supplement their income.

There is no commercial eel catching now and fishing is a sport, with the catch being returned to the water. Anglers play a vital role in checking on water pollution and ensuring that there is a healthy stock in our waters. The zander was not a native species but introduced from Eurasia in 1963 when released into the Great Ouse relief channel. Since then it has spread rapidly, liking the slow flowing water of the fens. It is related to the perch, but looks in appearance rather like a pike.

Bream, roach and tench are commonly found in fenland rivers. Many sections of the waterways belong to fishing clubs, and in Ely there is the Coopers Arms Club and the Beet Factory Club, which have bailiffs to ensure that fishermen comply with the season, but there are still some stretches of public fishing to be found. The sport is also enjoyed in private lakes stocked with carp and angling continues to be one of the country's largest leisure pursuits.

Fishing party from Ely, August 1909. (Photograph by Tom Bolton)